WHAT IS ANARCHISM?
An Introduction

Second Edition

Donald Rooum
Edited by Vernon Richards
Foreword by Andrej Grubačić

With excerpts from
Michael Bakunin, Alexander Berkman, Marie Louise
Berneri, Bill Christopher, Tony Gibson, William Godwin,
Emma Goldman, John Hewetson, Peter Kropotkin, Errico
Malatesta, Albert Meltzer, William Morris, George Nicholson,
Pierre-Joseph Proudhon, Vernon Richards, Jack Robinson,
Rudolph Rocker, Philip Sansom, Max Stirner, Peter Turner,
Nicolas Walter, Colin Ward, and Charlotte Wilson

2016

What Is Anarchism?: An Introduction, 2nd Ed.
© 2016 Donald Rooum
This edition © 2016 by PM Press

ISBN: 978-1-62963-146-2
Library of Congress Control Number: 2016930966

Cover by John Yates/stealworks.com
Interior by Jonathan Rowland

10 9 8 7 6 5 4 3 2 1

PM Press
PO Box 23912
Oakland, CA 94623
www.pmpress.org

Printed in the USA by the Employee Owners of Thomson-Shore
in Dexter, Michigan.
www.thomsonshore.com

CONTENTS

Arguments for Government Answered

The Relevance of Anarchism

Foreword
Andrej Grubačić

It is important to distinguish two periods in the history of anarchism. The period between 1870 and 1917 was the first anarchist moment. There is a wide agreement that this was the period when anarchism was the main revolutionary movement of the time. Eric Hobsbawm, a wonderful historian with an unfortunate ideological bias against anarchism, admits as much when he says that the nineteenth-century revolutionary movement was predominantly anarcho-syndicalist (Hobsbawm 1993, 72–73).

As the late scholar Benedict Anderson observed, "Between Marx's death and Lenin's sudden rise to power in 1917, orthodox Marxism was in the minority as far as leftist opposition to capitalism and imperialism was concerned—successful mainly in the more advanced industrial and Protestant states of Western and Central Europe, and generally pacific in its political positions" (Anderson 2010, xiv).

This was, by all accounts, a most remarkable period, yet anyone would have trouble finding much mention of it in traditional histories. The spectre of Eurocentric radical history still haunts interpretations of anarchism, a movement that is conventionally, and conveniently, reduced to a political ideology. But anarchism of this period was anything but a coherent ideology. Anarchist has always been anti-ideological, insisting on priority of life over theory. There has never been any finality in anarchist writings, as subjection to theory implied subjection to authority (Wieck 1996).

Anarchism, not an ideology but a tradition, was extremely flexible, allowing for selective adaptations from a very broad repertoire of anti-authoritarian ideas. Another distinctive anarchist quality was the particular nature of its propaganda efforts. Instead of fo-

cusing exclusively (and narrowly) on the urban industrial working class as a presumed agent of revolutionary change, anarchist propaganda was aimed at peasants, intellectuals, migrant and unskilled workers, industrial workers, artisans and artists. This facilitated the creation of a genuinely global radical culture in which multiplicity of radicalism converged around anarchism (Khuri-Makdisi 2010).

Ilham Khuri-Makdisi, one of the most brilliant historians of Mediterranean anarchism, suggests that

> in the parts of the world under semi-imperial, imperial, and colonial rule, calls for a more just society based on greater equality between different classes very often merged with anti-colonial struggles. These various radical networks—anarchist, anticolonial, revolutionist—often intersected and were entangled, both in terms of people and ideas, though this would probably no longer be possible a few decades later, with the subsequent hardening of communism, nationalism, and other ideologies, which made these radical movements' eclectic bricolage impossible—or at least much more difficult. (Khuri-Makdisi 2010, 25)

This appears to be one of the most important reasons for the unprecedented popularity of anarchism during the first anarchist century. Its "anti-ideological" nature and flexibility of anarchist writings allowed for intersections between anarchism and anti-colonial movements of the day.

Benedict Anderson, in his book on anarchism and anti-colonial imagination, writes that anarchism had a deep resonance in the periphery because it was not only hostile to imperialism, but also to colonialism. Anarchism was a trans-national, trans-oceanic movement of migrants and exiles, a revolutionary centre of vast radical network that connected militant struggles from Russia to Cuba (Anderson 2005).

This trans-oceanic movement showed an astonishing creativity in using new, popular media and new public spaces, such as li-

braries, reading rooms, mutual aid societies, taverns, and even theatres (Khuri-Makdisi 2010). Propaganda was not limited to texts: anarchists believed in the emancipatory force of literature, education, and music. There is a lesson here for contemporary anarchist movements, which would do well to rediscover relationships with local institutions, such as immigrant societies or local union halls. Anarchists' activists have instituted literacy campaigns, using anarchist periodicals written in accessible, simple language—often read aloud, as were many magazines that spoke to a population in which many were still illiterate. Here too there is a lesson for anarchist movements, especially those ensconced in places of higher learning and sophisticated discourse. If our politics is to be effective, our language needs to be simple and understandable, as well as beautiful. In Cuba, theatre was used for the purposes of education especially for the education of women. Aside from this informal education economy, anarchists produced a whole system of autonomous education, as well as pedagogical networks and internationals, such as the Libertarian League for Education. Francisco Ferrer's Modern School was one of the most celebrated educational institutions, one followed by networks of popular universities established by the anarchists in Paris in 1898, transported to Beirut and Alexandria. Then too there is Tolstoy's school, Yasnaya Polyana. Anarchists believed that the real social transformation, the real work of revolution, begins not in the factory but in the classroom, in a liberated school. A century or so later, anarchist interest in education, and interest in anarchist education, was revived by Herbert Read, Paul Goodman, Alex Comfort, Murray Bookchin, and other "new anarchists" in England and United States.

This would all change after 1917, when Marxism became a dominant strategic perspective for the antisystemic movements. This is the beginning of the Marxist century, but the shift did not happen immediately. Both social and national movements in the nineteenth and twentieth centuries went through a parallel series of great debates over strategy, which encompassed debates that raged

on between those whose perspectives were "state-oriented" and those who pushed instead for an emphasis on revolution as a process that does not involve taking the power of the state. For the social movement, this was the debate between the Eurocentric Marxist left and the anarchists; for the national-liberation movement, it was between political and cultural nationalists. Unfortunately, the ideas of socialism and social revolution became interchangeable with the idea of the nation-state as an institutional axis of the social revolution. This was premised on a two-step strategy: first task of the Revolution (with a capital *R*) was to seize the power of the state; the second was to change the world and create "new socialist humanity." Traditional historical materialism, very much in spite of Karl Marx, was transformed in a positivist project of liberal modernity, anchored in the ideology of progress as infinite economic expansion. Anarchist voices were erased, sometimes killed, and ultimately defeated in the historical struggle. State-defined and party-defined movements, those that came to be known as the Old Left, triumphed after the Russian Revolution in 1917. With immense cruelty, the twentieth century has shown that taking the power of the state is not enough, and that revolutionary project of changing the world by taking state power is a dangerous illusion.

The gradual disillusionment with bureaucratic socialism and the logic of the "Marxist century" would culminate during the world revolution of 1968. From Paris and Prague to Tokyo and Berkeley, activists of the so-called New Left eschewed state-socialist doxa of the Marxist Leninist ideology and rebelled against the two-step strategy of social change. I see 1968 as the beginning of the *new anarchism*, or of the second anarchist moment (1968–). Anarchist ideas became the core of the various New Left movements. New ideas were explored in depth, including social ecology and anarchist approaches to criminology, sexuality and housing. The influence of anarchist ideas only deepened after 1989 and the fall of state socialism. Since the 1990s anarchist or anarchist-inspired movements have grown everywhere; anarchist principles—

autonomy, voluntary association, self-organization, mutual aid, direct democracy—have become the basis for organizing within the globalization movement and beyond. As David Graeber (2002) points out, anarchism, at least in Europe and the Americas, has by now largely taken the place that Marxism once occupied before 1968. As a core revolutionary perspective, it is the source of ideas and inspiration, and even those who do not consider themselves anarchists feel they have to define themselves in relation to it.

Yet there are important differences between the two anarchist moments. In the period between 1870 and 1917 anarchism was a revolutionary perspective shared by artists and artisans, industrial workers and peasants, as well as by militant intellectuals. Anarchism was based in revolutionary organizations. Revolutionary syndicalism was predominantly, if not exclusively, anarchist in its political orientation. The most ambitious anarchist project, the Spanish Revolution of 1936, was a result of several decades of patient syndicalist organizing. Anarchist intellectuals were firmly anchored in revolutionary movements. After 1968 we have something of a paradox: anarchist ideas are indeed everywhere, but this is a different anarchism, one is even tempted to say anarchism without the anarchists. Anarchist organizations are relatively small and, to a large extent, politically insignificant. Organized anarchism appears to be stronger in the Global South, but not by much. In the Global North, anarchism is known for its many brilliant intellectuals, including outstanding figures such as Colin Ward and Alex Comfort in England, or Murray Bookchin, Noam Chomsky, and David Graeber in the United States. Paradoxically, despite the new technology, there is a significant (ideological and geographical) separation between anarchists in the periphery and anarchists in the core countries of the world system. Many of the anarchist-inspired activists of the anti-globalization, Occupy, and anti-austerity movements are students or educated but precariously employed workers who do not belong to any active anarchist organization. The most significant libertarian revolutionary experiments, includ-

ing the Zapatista autonomy in Mexico or the Kurdish democratic confederalism in Syria, have developed in an inspired dialogue with anarchist ideas, but these are not explicitly anarchist projects. What are the implications of all this for the character and future of anarchism in the second anarchist moment? Is anarchism a colourful and potent political counterculture, or is it a genuinely revolutionary global force? Is it a dominantly Euro-American phenomenon, or does this "new anarchism" speak to the realities of struggle in the South? In the long nineteenth century, anarchism served as a bridge between Western and non-Western practices of social interpretation and social transformation, and as a vehicle and instrument of translation of struggles. This was, without a doubt, the greatest strength of anarchism in the first anarchist moment. Is this still true today, in the midst of the present revival of anarchist practices? Essays collected in this magnificent book should be read as an opportunity to confront these complicated questions. It would certainly be a mistake to read these chapters as mere collection of dusty archival documents. Yes, this splendid book is an introduction to anarchism and testimony to it's magnificent past; but it is also much more than this. If we read it carefully, we might find important clues to engaging anarchism in new, constructive, and surprising ways.

REFERENCES

Anderson, Benedict. 2005. *Under Three Flags: Anarchism and the Anticolonial Imagination*. London and New York: Verso.

_____. 2010. Preface to *Anarchism and Syndicalism in the Colonial and Postcolonial World, 1870–1940*, edited by Steven Hirsch and Lucien van der Walt, xiii–xxix. London: Brill.

Graeber, David, 2002. "New Anarchists." *New Left Review* 13:61–73.

Hobsbawm, Eric. 1993. *Revolutionaries*. London: Abacus.

Khuri-Makdisi, Ilham. 2010. *The Eastern Mediterranean and the Making of Global Radicalism, 1860–1914*. Berkeley: University of California Press.

Wieck, David. 1996. "The Habit of Direct Action." In *Reinventing Anarchy, Again*, edited by Howard J. Ehrlich, 375–76. San Francisco: AK Press.

Anarchism: An Introduction

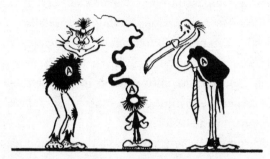

Anarchist characters from the Wildcat comic strip.
The Revolting Pussycat is impulsive and bad-tempered.
The Free-Range Egghead wants anarchism to be intellectually respectable.
The Mystery comes in when the story requires a third anarchist.

WHAT ANARCHISTS BELIEVE

ANARCHISTS BELIEVE THAT THE POINT OF society is to widen the choices of individuals. This is the axiom upon which the anarchist case is founded.

If you were isolated you would still have the human ability to make decisions, but the range of viable decisions would be severely restricted by the environment. Society, however it is organised, gives individuals more opportunities, and anarchists think this is what society is for. They do not think society originated in some kind of conscious "social contract" but see the widening of individual choices as the function of social instincts.

Anarchists strive for a society which is as efficient as possible, that is a society which provides individuals with the widest possible range of individual choices.

Any social relationship in which one party dominates another by the use of threats (explicit or tacit, real or delusory) restricts the choices of the dominated party. Occasional, temporary instances of coercion may be inevitable; but in the opinion of anarchists, established, institutionalised, coercive relationships are by no means inevitable. They are a social blight which everyone should try to eliminate.

Anarchism is opposed to states, armies, slavery, the wages system, the landlord system, prisons, monopoly capitalism, oligopoly capitalism, state capitalism, bureaucracy, meritocracy, theocracy, revolutionary governments, patriarchy, matriarchy, monarchy, oligarchy, protection rackets, intimidation by gangsters, and every other kind of coercive institution. In other words, anarchism opposes government in all its forms.

In a government society, anarchists may in practice apply to one coercive institution for protection from another. They may, for instance, call on the legal establishment for protection against rival governments like violent criminals, brutal bosses, cruel parents, or fraudulent police. "Do as I say or I'll smash your face in" is often a more frightening threat than "Persons guilty of noncompliance are liable to a term of imprisonment," because the perpetrator of the threat is less predictable. But the differences between different levels and forms of coercive institutions are less significant than the similarities.

For dictionary purposes, *anarchism* may be correctly defined as opposition to government in all its forms. But it would be a mistake to think of anarchism as essentially negative. The opposition to government arises out of a belief about society which is positive.

Anarchy

The ideal of anarchism is a society in which all individuals can do whatever they choose, except interfere with the ability of other individuals to do what they choose. This ideal is called *anarchy*, from the Greek *anarchia*, meaning absence of government.

Anarchists do not suppose that all people are altruistic, or wise, or good, or identical, or perfectible, or any romantic nonsense of that kind. They believe that a society without coercive institutions is feasible, within the repertoire of natural, imperfect, human behaviour.

Anarchists do not "lay down blueprints for the free society." There are science-fiction stories and other fantasies in which anarchies are imagined, but they are not prescribed. Any society which does not include coercive institutions will meet the anarchist objective.

It seems clear, however, that every conceivable anarchy would need social pressure to dissuade people from acting coercively; and to prevent a person from acting coercively is to limit that person's choices. Every society imposes limits, and there are those who argue, with the air of having an unanswerable argument, that this makes anarchism impossible.

But anarchy is not perfect freedom. It is only the absence of government, or coercive establishments. To show that perfect freedom is impossible is not to argue against anarchism, but simply to provide an instance of the general truth that nothing is perfect.

Of course, the feasibility of anarchy cannot be certainly proved. "Is anarchy practicable?" is a hypothetical question, which cannot be answered for certain, unless and until anarchy exists. But the question "Is anarchy worth striving for?" is an ethical question and to this every anarchist will certainly answer yes.

"Anarchy" in the Sense of Social Disorder

Besides being used in the sense implied by its Greek origin, the word "anarchy" is also used to mean unsettled government, disorderly government, or government at its crudest in the form of intimidation by marauding gangs ("military anarchy").

This usage is etymologically improper, but as a matter of historical fact it is older than the proper one. The poet Shelley held opinions which are now called anarchistic, but in his poem "A Mask of

Anarchy, written on the Occasion of the Massacre at Manchester," he uses the allegorical figure of "Anarchy" to mean tyranny. (The poem was published several years after it was written, and by that time anarchists were beginning to call themselves anarchists.)

Both the proper and improper meanings of the term "anarchy" are now current, and this causes confusion. A person who hears government by marauding gangs described as "anarchy" on television news, and then hears an anarchist advocating "anarchy," is liable to conclude that anarchists want government by marauding gangs.

Some anarchists have tried to overcome the confusion by calling themselves something different, such as autonomists or libertarians, but the effect has been to replace one ambiguity with another. "Autonomy" (which means making one's own laws) commonly refers to "autonomous regions," secondary governments to which some powers are devolved from the principal government. "Libertarian" is used in America to mean one who opposes minimum wages, on the grounds that they reduce the profits of employers.

The simplest way to avoid confusion would be to reserve the term "anarchy" for its etymologically correct meaning, and call social disorder by some other term, such as "social disorder." Enlightened journalists are already following this practice.

Anarchism and Terrorism

The word "terrorism" means planting bombs and shooting people for political ends, without legal authority. Wars use much bigger bombs, kill many more people, and cause much more terror, but wars do not count as terrorism because they are perpetrated with legal authority.

Terrorism has been used by anarchists. It has also been used by Catholic Christians, Protestant Christians, Mohammedans, Hindus, Sikhs, Marxists, fascists, nationalists, patriots, royalists and republicans.

The vast majority of anarchists, at all times and places, have opposed terrorism as morally repugnant and counterproductive. So have the vast majority of Christians and so on, but in their cases it is not necessary to say so. In the case of anarchists it needs to be emphasised that they abhor terrorism, because malicious and ill-informed persons sometimes portray anarchists as wild-eyed bombers with no opinions at all, just an insane urge to destroy.

The "anarchist bomb-thrower" is a folk-myth, mostly derived from literature. It was originated in the "penny bloods" of the nineteenth century, and revived with gusto by the writers of "boys' stories" in the early 1920s, when war was out of fashion but fictitious heroes still needed enemies.

Let it be emphasised. Only a small minority of terrorists have ever been anarchists, and only a small minority of anarchists have ever been terrorists. The anarchist movement as a whole has always recognised that social relationships cannot be assassinated or bombed out of existence.

Some Arguments for Government

The difficulty of arguing the anarchist case today has been compared with the difficulty of arguing the atheist case in medieval Europe.

In the middle ages people never wondered whether God existed; they just assumed, without ever considering the matter, that the existence of God was self-evident. In our time people never ask themselves whether government is necessary; they just assume that the necessity is self-evident. And when anarchists question the need for government, many people fail to understand the question.

It was once put to me as an argument against anarchism, that "if everyone could choose what to do, no one would elect to join the army, and the country would be undefended." My interlocutor was not an idiot but could just not imagine a world without "countries" that needed armies to defend them against foreigners.

Bemused people ask how anyone could be induced to work if there were no coercion ("who will clean the sewers?"). Yet everybody knows that being forced to do things is not the only reason for doing things. Rich people who can afford to do nothing, workers in their "own" time, people who enjoy their jobs, even people who ask how anyone could be induced to work if there were no coercion, do things for other reasons.

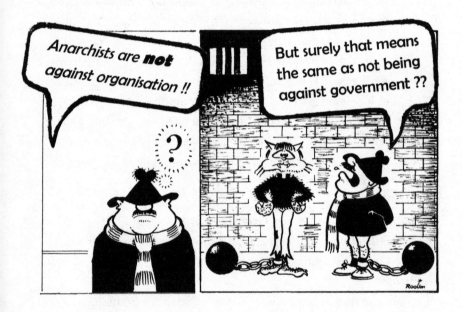

People who work in sewers have told me they are proud of the importance of their job. People do things because they enjoy doing them, or are proud of their skill, or feel empathy with the suffering, or are admired for what they do, or get bored doing nothing.

Fear of the lash, or penury, or hellfire, is not needed for inducing people to do useful things. It is needed to make people endure the stressful indignity which working-class people call "work": responsibility without power, pointless drudgery, being talked down to by morons. Anarchists believe that everything worth doing can be done without "work."

Many people confuse government with organisation, which makes them suppose that anarchists are against bandleaders and architects. But organisers and leaders are not the same as bosses. Anarchists have no objection to people following instructions, provided they do so voluntarily.

Some who concede that organisation occurs without government insist that government is necessary for large or complex organisation. People in anarchy, they say, could organise themselves up to the level of agrarian villages but could not enjoy the benefits of hydroelectric schemes and weather satellites. Anarchists, on the other hand, say that people can organise themselves freely to do anything they think worthwhile. Government organisation is only needed when the job to be organised has no attraction for those who do it.

Government is even thought by some to be responsible for pair-bonding. Until quite recently a couple might live together for years and bring up a family, yet their love would still be classed as a casual affair if they did not have a marriage licence from the state.

Another daft argument for government is that people are not wise or altruistic enough to make their own decisions, and therefore need a government to make decisions for them. The assumption behind this contention is either that the government does not consist of people, or that the people in government are so wise and altruistic that they can not only make their own decisions but also make decisions for others. But everyone can see that getting into power does not require wisdom or altruism; the essential qualification is to be keen on getting into power.

A particular instance of the argument, that people are not responsible enough to make their own decisions, is the contention that children need "discipline" to prevent them from growing up antisocial. Anarchists have compared this to the old argument that babies need to be tightly bound, to prevent them from injuring themselves by kicking.

It is hundreds of years since swaddling bands have been used, but there has still not been a single instance of a baby injuring itself by kicking. Nor has there been an instance of a child being spoiled by the rod being spared. Children benefit from a stable environment, but that is not the same as an authoritarian one.

Governments as Steps towards Anarchy

There are theories on both the left and right of politics which advocate a planned sequence of societies, culminating in anarchy but beginning with a new kind of authoritarian society.

Best known of these is classical Marxism, which holds that the state will wither away, when people are so equal and interdependent that they no longer need restraint. The first step towards this goal is to impose a very strong government, of people of good will who thoroughly understand the theory.

Wherever Marxists have seized power, they have behaved like other people in power. Marxists accuse them of betraying the revolution, but anarchists think the pressures of power make all bosses behave in substantially the same way. (The anarchist Michael Bakunin predicted as early as 1867 that Marxist government would be "slavery and brutality.")

There are self-styled "anarcho-capitalists" (not to be confused with anarchists of any persuasion), who want the state abolished as a regulator of capitalism, and government handed over to capitalists. Many go no further, but some see the concentration of power in the hands of capitalists as the first step towards a society where every individual is his or her own boss.

Other forms of government advocated as intermediate steps on the road to anarchy are world government, proliferation of small independent states, government by priests, and government by delegates of trade unions.

The anarchists, and the anarchists alone, want to get rid of government as the first step in the programme.

This does not mean they suppose government can be abolished overnight. It means they think the idea of educating people for freedom, by intimidating them into submission, is an absurd idea. Anarchists struggle for freedom from coercive institutions by opposing coercive institutions.

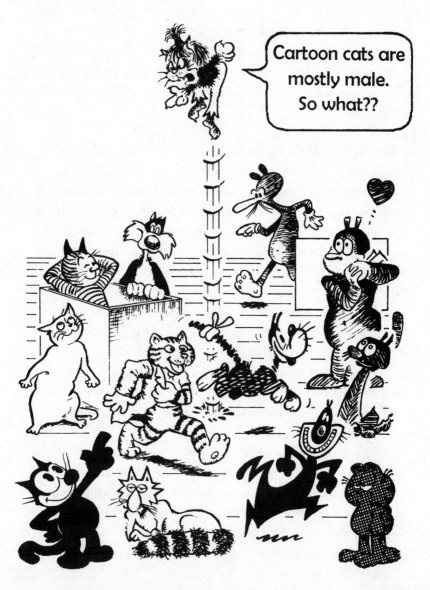

Until and unless a society free of government exists, nobody can be absolutely certain that such a society is feasible. If it is not, then Marxists and others who set up a strong government in the hope of eliminating government do not just fail to attain their objective but end up with more of what they were hoping to eliminate. Anarchists at least give themselves a chance of ending up with a society freer than it would otherwise have been.

Reformists measure progress by how near they are to attaining power. Anarchists measure progress by the extent to which prohibitions and inequalities are reduced, and individual opportunities increased.

The Origin of Government

For most of its existence, the entire human species lived by foraging. Modern foraging societies inhabit widely different environments, in rainforests, tropical deserts, and the Arctic. Nevertheless they have similar ways of social organisation, so it seems reasonable to suppose that prehistoric foragers were similarly organised.

There are no rulers, bosses, chieftains, or elected councils. Day-to-day decisions are made by consensus. The rules of good behaviour are decided by custom and consensus, and enforced by what some anthropologists call "diffuse sanctions."

Anarchists do not advocate return to a foraging economy but use the fact that our ancestors lived for a million years without government as evidence that societies without government are viable.

This leaves anarchists with a question to be answered. If the first human societies were anarchies, then the first government must have arisen out of anarchy. How can this have happened?

There is no historical record of the event, because writing was not invented until governments were well established. But there are plausible conjectures, consistent with archaeological and anthropological evidence.

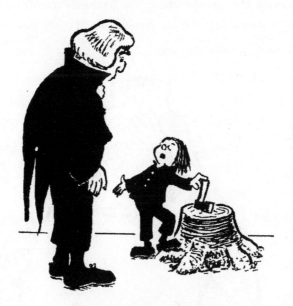

"I can't tell a lie, Pa"

Farming people, unlike foraging people, need to predict the cycle of seasons, so that they know when to do the planting. For early farmers, the method of prediction was to observe and remember the movements of the stars, a skilled job which must be done when most people are asleep. Perhaps early farmers had specialists in weather prediction. Perhaps these specialists acquired a reputation for actually controlling the weather and were given privileges in return for ensuring that the seasons followed the required sequence.

A reputation for magical power does not in itself, however, make anyone into a boss. Anarchists see a more likely origin of government in systematic robbery.

Early farmers were probably harassed by foragers, who would of course regard a field of crops as a bonanza. There may also have been ex-farmers turned robbers because their crops had failed. Perhaps some of the robbers learned to take only part of the pro-

duce, leaving the farmers enough to live on. Perhaps they made themselves tolerable to the farmers by driving other would-be robbers away.

Anyway, by the time writing was invented the functions of weather controller and robber-defender were combined in the same person. A formidable combination of magic and coercion.

All over the world, there were royal families considered to be demigods, and a member of the royal family was chosen to become a god or the messenger of God, chief priest, absolute ruler, lawgiver, and supreme commander of the armed forces.

Monarchy remained the universal form of top government for thousands of years, and most states retain some of its ritual trappings.

Democracy

"Government of the people, by the people, for the people" is a poetic phrase which uses "the people" in three different senses: the people as a collection of individuals, the people as the majority, and the people as a single entity. In prosaic terms, it means power over individuals, exercised by the majority through its elected officers, for the benefit of the whole population. This is the ideal of democracy.

Voters in a democratic election contribute to the choice of who shall exercise power on behalf of the majority, and in doing so consent to be ruled by whoever the majority chooses.

For five thousand years, monarchy was the mark of civilisation. In less than two hundred years, the norm of civilisation has become democracy. Military usurpers used to claim either that the throne was rightfully theirs or that they were acting on behalf of the monarch. Military dictators today claim either that they have a mandate from the people or that they are going to organise elections when order has been restored.

It used to be generally accepted that people had a duty to surrender their power unconditionally to a hereditary monarch. Now the accepted form is for citizens to surrender their power periodically to rulers chosen by majority voting.

Anarchists are against the surrender of power and therefore against democracy. Not just against the perversion of democracy

(though that is often mentioned) but against the democratic ideal. They do not want people to give power to whoever they choose; they want people to keep their power for themselves.

Making Progress towards Anarchy

Anarchists are extreme libertarian socialists, "libertarian" meaning the demand for freedom from prohibition, and "socialist" meaning the demand for social equality.

Freedom and equality are sometimes represented as antagonists, but at the extremes they coincide. Complete freedom implies equality, since if there are rich and poor, the poor cannot be permitted to take liberties with riches. Complete equality implies freedom, since those who suffer restrictions cannot be the equals of those who impose them.

Anarchists will not be content with anything less than complete freedom and complete equality, but they do not have an all-or-nothing attitude. They value partial freedom and partial equality. This is shown by the angry enthusiasm with which anarchists have agitated against the poll tax, the commercialisation of the National Health Service, anti-immigration laws, bad prison conditions, and the imprisonment of innocent persons.

Anarchists do not, however, help anyone to take power. They do not deny the sincerity of those who wish to use power for the improvement of society, but nobody can use power for anything, unless they first obtain it. The first aim of people seeking power, whatever they intend to do with it, must be to get and keep as much power as possible. As a guide to action, anarchists assume that the *first* aim of power-seekers is the *only* aim. This is not the whole truth, but it is close enough for practical purposes.

The anarchist strategy for improving society is to influence public opinion. In the long run, rulers need the consent of the ruled. No government, however despotic, can keep going if it gets too much out of tune with public attitudes. If enough ordinary peo-

ple are determined on some particular relaxation of government, then the government must either concede or fall.

A subtle indicator of anarchist success is a gradual diminution of respect for authority generally.

A more obvious but paradoxical indicator of success in anarchist endeavours (in alliance with those seeking particular partial freedoms) is legislation, for instance the Acts of Parliament ending conscription, or prohibiting corporal punishment in schools. Apologists for government represent such legislation as a benefit of government. As anarchists perceive it, however, governments refuse to give up any power at all, except as an alternative to losing power entirely. When they are forced to surrender a little, they are astute enough not to do so with a grudging expression, but to wear a smile of generosity.

Freedom of speech and assembly, freedom from utter penury, freedom of access to water and medicine, which would have been considered utopian dreams in this country a couple of centuries ago, are now considered ordinary. In the anarchist view, these freedoms were not given by kind-hearted rulers, but conceded by bosses who felt threatened. And public pressure must be maintained, to deter the bosses from taking back what they have conceded.

By and large, the structure of society conforms to what most people think is right. If most people are persuaded by a small part of the anarchist message, the result is a small lessening of prohibitions or inequalities, a small widening of individual choices. The change may occur peacefully, or it may take an insurrection. The new structure of society then becomes the ordinary structure, from which people may be persuaded to demand a further widening of choices.

Every anarchist would like everyone in the world to be suddenly persuaded of the whole of the anarchist message, and for the change from oppression to anarchy to happen in a single, fantastic, revolutionary leap. But as realists, anarchists also value creeping progress in the right direction.

Anarchists do not agree about everything

HOW ANARCHISTS DIFFER

Misapplications of the Term "Anarchist"

An anarchist is one who opposes government in all its forms. But sometimes the term "anarchist" is misapplied to persons who do not in the least conform to the definition.

Sometimes "anarchist" is wrongly used for people who use illegal means for political ends which are not anarchist. Guy Fawkes, for instance, is sometimes described as an anarchist, although his aim was to replace the oppressive English regime with one resembling the Spanish, which was even more oppressive. A recent British group, given to destroying magazines in bookshops, called themselves "anarchists" although their aim was an increase in censorship.

Another misapplication of the term "anarchist" is to anyone bloody-mindedly fixed in their opinions. I once heard a drunk on a bus, loudly advocating all sorts of authoritarian measures, including conscription, capital punishment, and "send the farkin wogs back," with occasional repetitions of "If anyone disafarkingrees, let 'em farking disagree. I ain't farkin inristid, I'm a farkin anarchist."

There are also "anarchist" poseurs, like the sartorial stylists who paint A-in-a-circle symbols on their leather jackets without having the least interest in anarchism as an idea, and wrongly self-styled "anarchists" ("anarcho-capitalists") who want to abolish the state as a regulatory and welfare institution but do not oppose capitalist oppression.

Differences among Real Anarchists

Anarchism, properly defined, embraces a wide range of different opinions, but differences of opinion do not in themselves lead to splits in the movement. Pacifist anarchists work alongside advocates of class violence, atheists alongside mystics, with occasional heated arguments but without rancour.

Let me not give the impression that anarchists never quarrel. There are deep and damaging splits, in which anarchists slag each other off as cheats, liars, thieves, agents of the secret police, and repulsive persons generally. But the basis of such splits is personal antagonism, and it is rare in the anarchist movement for personal quarrels to be masqueraded as doctrinal disputes.

Intellectualists and Workerists

The difference which most often causes anarchists to separate into different groups is a difference, not of political opinion, but of presentational style. Some anarchists like to present anarchism by explaining the ideas and arguing the case. Others are impatient of argument, preferring blunt statements and calls to working-class action.

In banter, they have referred to each other as "people who like to think of themselves as intellectuals" and "people who like to think of themselves as working-class."

The difference is not one of social class or educational background. "Intellectualists" include manual workers whose formal education stopped at compulsory school-leaving age or before, intellectual only in the sense of intelligent and thoughtful.

"Workerists" include highly educated individuals from rich families, working-class only in the sense that at some time or other they have been paid, or expect to be paid, for doing something.

Where there are anarchists in sufficient numbers, intellectualists and workerists tend to organise separately. They exchange jocular insults, but in general they respect each other's different tastes, and recognise that they complement each other's efforts by addressing different audiences. When it seems useful, the work together amicably enough.

Individual Anarchism *Is* Class-Struggle Anarchism

Many anarchists call themselves by secondary labels. Some, such as "pacifist anarchist" and "anarcho-syndicalist," indicate a difference of opinions from other anarchists. Others, such as "anarchist communist" and "anarchist socialist" are just there to distinguish persons of anarchist persuasion from persons to whom the term "anarchist" is misapplied.

In modern parlance, "class-struggle anarchist" and "individual anarchist" are labels of the latter type.

A hundred years ago, "individualism" was used to mean competitiveness, and self-styled "individualist anarchists" had ideas something like those of the "anarcho-capitalists" of our time. Today, the term "individualist" is applied to anarchists who emphasise the importance of individuals.

Much more recently, the term "class-struggle" was used by adherents of an authoritarian political movement which denied the importance of individuals and extolled a faceless amalgam, significantly called "the masses." Those who now call themselves "class-struggle anarchists," however, are simply anarchists who emphasise that the struggle against oppression can only be won by oppressed individuals acting on their own behalf.

Self-styled class-struggle anarchists and self-styled individual anarchists are not in disagreement. The different choice of labels indicates no more than a difference of emphasis. They sometimes think they disagree, and suspect the bona fides of each other's anarchism, but this is entirely the result of obsolete word associations.

It may be conjectured that those who style themselves class-struggle anarchists tend to the "workerist" taste, and individualist anarchists to the "intellectualist"; but if such a correlation exists at all, it is certainly not exact. Some taciturn activists call themselves individualists, and some self-styled class-struggle anarchists delight in hair-splitting verbosity.

Revolutionary Violence and Pacifist Anarchism

With a few exceptions, anarchists are agreed that wars between governments should never be supported, and that group violence is acceptable only if it is used in furtherance of the anarchist revolution. The difference of opinion is about how much violence is useful.

At one extreme are those who argue that the revolution can only succeed if it involves no violence whatever. They contend that

a society established by violent defeat of the bosses could only be maintained by violent suppression of the ex-bosses. Therefore violence cannot lead to anarchy, but only to a change of bosses.

At the other extreme are those who hold that any fighting between working-class people and the forces of authority, whatever the immediate motive and whoever wins, contributes to the revolution by showing that the bosses can be resisted. Anarchists of this persuasion have sometimes joined peaceful demonstrations and tried to provoke the police into attacking the demonstrators. (Anarchists are sometimes said to have caused riots by instructing peaceful demonstrators to attack the police. This is a ridiculous accusation. If people riot it is because they are angry, not because someone tells them to riot.)

Between the extremes of pacifism and bellicosity, most anarchists think violence is useful at some times but counterproductive at other times. In general they dislike violence because it is likely to end in defeat or injury, but they applaud successful risings, for instance the defeat of Ceausescu in Romania.

Anarchists have often joined armed resistance groups as individuals, and anarchist armies fought in Ukraine and Mexico in the 1920s, in Spain in the 1930s, and in Korea under Japanese occupation in the 1940s. In those countries now, the common stereotype of an anarchist is not a "mad bomber" but a freedom fighter.

There are anarchists now alive, who volunteered to fight against Franco in Spain, went to prison rather than join the British army to fight Hitler, and vociferously opposed the recent war against Saddam Hussein. They might be accused of inconsistency, in that they took arms against one dictator, but refused to take arms against two others equally bad.

In fact, however, their attitude is quite consistent, because it is positive. They act on their perception of what wars are *for*, rather than what they are against. The stated objective of the war against Saddam Hussein was to restore the monarchy in Kuwait. The stated objective of the war against Hitler was to preserve the British

Empire. The stated objective of the anarchist fighters in Spain was a free society. Of these, only the objective of the Spanish war was considered worth fighting for.

Workers' Control and Anarcho-Syndicalism

All anarchists believe in workers' control, in the sense of individuals deciding what work they do, how they work, and who they work with. This follows logically from the anarchist belief that nobody should be subject to a boss.

"Workers' control" is also used with another meaning, that of power being vested in the workers collectively, and exercised in practice by elected officers of the workers. This idea is called syndicalism, from *syndicat*, the French for trade union.

Elaborate constitutions have been invented, for syndicalist systems of government. Typically there are to be workplace committees consisting of directly elected delegates, local committees consisting of delegates from workplace committees, and so on up the pyramid to a delegate committee which has overall control of industry. Delegates are also sent to local and national legislatures. The pyramid structure ensures that electors at different levels know their delegates personally, and delegates can be recalled at any time, which prevents them from making decisions contrary to the electors' wishes.

The purpose of such proposed constitutions is not anarchistic but democratic; not to get rid of government, but to make government accountable.

A looser meaning of syndicalism, however, is quite compatible with anarchism. This is simply to use the power of the trade unions, not just to secure better wages and conditions, but to bring about real social change. If the social change is towards anarchy, this is called anarcho-syndicalism.

Many anarchists active in trade unions are anarcho-syndicalists. Other anarchist trade unionists, however, disagree with anarcho-syndicalism. They contend that an effective trade union must

include workers of every political persuasion, whereas an effective movement for social change must restrict its membership to those who favour social change.

Anarchism and Religion

The religious or anti-religious opinions of most anarchists are intertwined with their political beliefs.

"Neither God nor master" is a traditional anarchist slogan, expressing the belief that God is a lie, invented to make slavery bearable. Many anarchists were atheists first and became anarchists later, after rejection of divine authority had cleared the path for rejection of human authority.

Many anarchists embrace conscious egoism, the doctrine that it is absurd to call shame on selfishness, because selfishness is unavoidable. The universe has no absolute centre; for a sentient being, the practical centre of the universe is the point from which the universe is perceived: the self. For God (if God exists), the centre of the universe is God. For me, the centre of the universe is me.

The notion of a supreme Deity, "a tyrant in Heaven," is considered an excuse for tyrants on Earth, by anarchists who are atheists, conscious egoists, humanists, and agnostics.

On the other hand, there are anarchists for whom the worship of God is the very basis of their anarchism. They may believe that human authority is an affront to divine authority. Or they may believe on religious grounds that war is wrong, and on empirical grounds that war is inseparable from government.

There are Christian, Buddhist, Jewish, Taoist, Hindu, and Neopagan anarchists, for all of whom anarchism and religion are inextricable, as surely as anarchism and anti-religion are inextricable for other anarchists. One Neopagan has described the summer solstice gathering as "the principal event in the anarchist calendar."

Anarchism implies tolerance of different beliefs, so long as those beliefs do not involve coercion. Religious and anti-religious anarchists may argue, but they do not reject each other. There are those, however, who think the term "Christian anarchist" an absurd self-contradiction.

Animals

Anarchists are averse to suffering, and most are concerned to prevent suffering in nonhuman animals as well as humans. There have always been anarchists who were also vegetarians and vegans, and most meat-eating anarchists take an interest in humane slaughter.

Recently there has developed an animal welfare movement which goes beyond animal welfare to animal liberation, and with it a school of anarchist thought which sees human liberation as a special case of animal liberation.

Communism, Collectivism, Mutualism

Although anarchists are careful not to "lay down blueprints for the free society," they have arguments about what kind of social arrangements are compatible with freedom from authority. Some anarchists are communists in the strict sense, maintaining that all goods should be held in common. Others allow private ownership at individual and community levels, but not ownership of a factory in which non-owners do the work, or ownership of land on which non-owners pay rent. Property in that sense is seen as theft.

Barter is rejected by anarchists, as any system which exchanges goods of equal value is designed to make sure the rich remain rich and the poor, poor. Money is also rejected by most anarchists, as no more than a system of trade tokens for the simplification of barter.

Some anarchists, however, believe that the banking system is fundamentally different from the barter system, and that money,

We did grow some food, but it was exported to Europe and fed to cattle.

not as trade tokens but as banking units, is essential for any complex economic undertaking. They think a central bank need not be a coercive institution, and must be a feature of any anarchy more complex than a series of self-sufficient agrarian communities.

This idea, called collectivism or mutualism, is not accepted by very many anarchists today but was embraced by many nineteenth-century anarchists whose work is still published and respected.

Optimists and Pessimists

Anarchists have different opinions about how closely and how quickly the ideal of anarchy can be achieved.

It seems to some young anarchists that anarchism is so sensible and obvious that everybody must agree with the idea as soon as they hear about it. These young anarchists are convinced that the revolution can be completed within a short time, if it is urged with enough energy.

Anarchists who have been in the anarchist movement for some time feel compelled to recognise that society is resistant to rapid change. The anarchist revolution has been urged for well over a century, but few have been convinced and progress is very slow.

There are various responses to this recognition. Some retire from the anarchist movement in disillusion.

Others just retire their political thinking from the real world and persist willy-nilly in the conviction that one of these days the workers will suddenly understand the message and government will be abolished in a twinkling. There is a group identified by some as anarchists (though they reject the term themselves), whose principal activity is to meet regularly and reiterate their faith in the coming, sudden, world revolution, in the manner of a religious group reiterating their faith in God.

There are anarchists who believe that wars and war preparations, penury, intolerance, oppression, and other features of gov-

ernment are permanent features of society, and that therefore the only role for anarchists is "permanent protest," calling attention to the injustices of society without hoping to change anything much.

A more optimistic idea is that "the anarchist revolution is now," Society is not permanently fixed, but in a permanent state of transition, mostly slow but occasionally rapid. Some changes make government stronger and some make it weaker; but for the past few centuries, it can be argued, the overall trend of social change has been in the direction of wider individual choices.

Nobody makes the implausible claim that anarchist agitation has been solely, or mainly, responsible for this beneficial change. But optimistic, "revolution-is-now" anarchists believe that anarchism has made, and is still making, a useful contribution.

No, madam, I don't suppose you have seen a sunset like that.

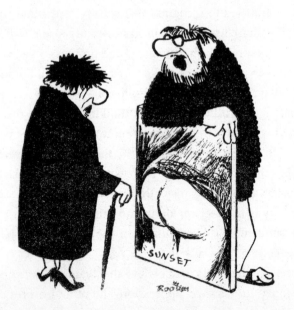

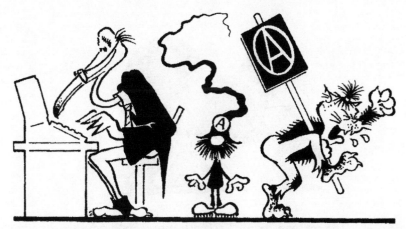

Anarchists in the UK mostly try to spread the idea

WHAT ANARCHISTS DO
(in the UK since World War II)

The first two sections of this introduction, "What anarchists believe" and "How anarchists differ" are unrevised reprints of those in the 1992 Freedom Press edition. This third section is updated and revised. It describes anarchist activities in Britain since the 1940s, in general terms, without mentioning personal names. Donald Rooum is personally responsible for the opinions and any errors.

Anarchist Bombs

Bombs and assassinations are not mentioned in the 1992 edition, because anarchist bombs could be too easily confused with bombs connected with "The Troubles," *i.e.* the tribal conflict in Northern Ireland. (The conflict there is no longer exported to England, Scotland, and Wales, following the introduction of Power Sharing, a constitutional device by which the minority "Irish," aka "Nationalists" aka "Taigs." have equal civil rights with the "British," aka "Loyalists" aka "Prods.") Recent bombs and outrages, by the Jihadi movement, are never attributed to anarchists.

**The cartoon "bomb", a black sphere with a fuse,
was only ever used by government forces.
It was a military weapon, a hollow cannonball full of explosive stuff,
first used by General Henry Shrapnel in about 1809.**

Taking Explosives to Spain

In August 1964, there was an international anarchist camp in Toulon. An eighteen-year-old school student from Britain was expected to get there by hitchhiking but failed to arrive. His friends were worried. Then it was announced that he had been arrested in Barcelona, and charged with carrying chemicals for making bombs.

He sent a telegram, "Please believe in my innocence," in the light of which it was believed that, for some obscure reason, the Spanish security service had apprehended an innocent British lad hitchhiking in France. Anarchists and others campaigned for his release, at first on the basis that he was innocent, but always making it clear that if the unlikely charge was true, our comrade still deserved our support. As a *Freedom* editorial put it (29 August 1964): "But if he is guilty? Then, in our opinion, the efforts of all good men must be redoubled. . . . For what will count, what will remain in people's minds, is the noble intention."

On 1 September, he appeared before a military court in Madrid and agreed with the prosecution that he had indeed been smug-

gling explosives. It was obvious, from the confidence with which he contradicted details of the police account, that he had not been drugged or tortured into confessing.

After telling people that he wanted to do something practical for the Spanish revolution, he had been introduced to a group of Spanish anarchists in France, who supplied him with the materials for an explosive device, and sent him off to Barcelona, hitchhiking, unable to speak Spanish, wearing a Scottish kilt and a bulky woollen jumper (to conceal the explosives taped to his skin). It must have been easy for the Spanish police to monitor his movements.

He was sentenced to twenty years' imprisonment and released after three years. (The Spanish penal regime was one of horrific sentences mitigated by frequent amnesties.) Freedom Press and the anarchist movement in Britain had kept up a campaign of demonstrations and appeals for his release. It seems, however, that as he had been persuaded that the people who sent him to Spain with explosives were genuine anarchists, he was now persuaded that the genuine anarchists who had worked for his release were "pacifists," who had withdrawn their support when they knew he really had been carrying explosives.

The Angry Brigade

The Angry Brigade, "Britain's first urban guerrilla group," did not describe itself as anarchist, but as "revolutionary." Its First Communiqué (*i.e.* letter to *The Times* newspaper), in December 1970, claimed responsibility for a machine-gun attack on the Spanish Embassy "in solidarity with our Basque brothers and sisters." This was later said by police to be the eighteenth in a series of bombs and shootings by the same group, using various names, beginning with the First of May Group in 1966. In all, twenty-five incidents were attributed to them. Their attacks, their communiqués stated, were against buildings, not against persons. If their bombs had accidentally killed or injured anyone, they would no doubt have been horrified.

Sixteen suspects (including the chap who had smuggled explosives into Spain) were arrested, and nine of them acquitted, some of them after months on remand in custody. In December 1971, one was convicted of placing a small bomb on the windowsill of a house, and sentenced to fifteen years, later reduce to ten years. Eight, the "Stoke Newington eight," were on trial from May to December 1972, when four were released and four were sentenced to ten years each.

Newspapers (not the police) associated the Angry Brigade with a bomb at the top of the new Post Office Tower, and one newspaper illustrated the story with a photograph of damage caused by a massive bomb at a shopping mall in Manchester. As the newspapers knew well, these bombs had nothing to do with the Angry Brigade, but were claimed by the Irish Republican Army.

The "Persons Unknown" Case

In 1978, five people were arrested and charged with "conspiring with persons unknown to cause explosions." One of them, a woman, was kept in a men's prison because she was deemed too dangerous for a women's prison. After twenty months, the charge was changed to "conspiracy to rob" and the suspects were released on bail. When they came to trial, one of the five pleaded guilty. One of the remaining four conducted his own defence, while the others were each represented by eminent Queen's Counsel. In 1980, after the longest criminal trial in English history, they were found not guilty. The judge was furious. He ordered the jury to come back to court on a Saturday morning to hear the "confession" of the man who had pleaded guilty.

The defendant who conducted his own defence went on to become a successful writer, author of novels and television scripts, and a newspaper chess column. The man who pleaded guilty was sentenced to nine years. The judge retired and got a job on television, judging small claims disputes as entertainment.

The McLibel Case

The longest case of any kind in any British court was a libel suit brought by the McDonald's Corporation against an anarchist group called London Greenpeace (no connection with International Greenpeace).

In 1986, London Greenpeace issued a leaflet, *What's Wrong with McDonalds?*. McDonald's hired two firms of private investigators to infiltrate the group to ascertain personal names, and in 1990 issued writs against five individual members. Three of them gave in under threats, while the remaining two opted to go for trial. In 1993, McDonald's lawyers applied successfully for the case to be heard without a jury, on the ground that the evidence would be too technical. This meant that everyone in court—lawyers, judges, officials, and plaintiff's witnesses—would be paid by the day, apart from the defendants who were happy to be there. So there was no pressure to get the case finished early.

In 1994, McDonald's issued a leaflet of their own, saying the case was not about freedom of speech but about whether people were allowed to tell lies, and the defendants brought a counter-claim, saying that they had been subject to libellous accusations of lying. In 1998, it emerged in court that the London police had assisted McDonald's with information, and the Metropolitan Police was ordered to pay the defendants £10,000 plus legal costs.

In 2000, the case ended and the judge dismissed most of the complaints but awarded McDonald's £60,000 damages, a small fraction of their legal costs, which McDonald's announced they would not attempt to collect. In 2005, the European Court of Human Rights ruled that the defendants had been denied a fair trial and ordered the British government to pay them £57,000 in compensation.

Cooperating with Others

Anarchists are against all coercive institutions and practices but in practice concentrate on the institutions which seem most vulner-

able at the time, "the soft underbelly of government," This means that in almost every instance of anarchist activity, we are allied with people who are not anarchists, but opposed to particular features of particular authorities.

Many people besides anarchists resisted conscription in World War I, and all were remembered together in the centenary meetings. There was a similar alliance of resistors to World War II. At the beginning this alliance included the Communist Party. When Germany invaded Russia in July 1941, the Communist Party suddenly turned aggressively pro-war, and its members reported their erstwhile allies to the authorities. Older anarchists have mistrusted the Communist Party ever since.

Anarchists were prominent in the successful campaign against the poll tax (Community Charge), imposed not only on property owners, but equally on all users of services provided by local authorities, including the destitute and homeless. This was introduced in Scotland in 1989 and the rest of the UK in 1990, and resistance to it ended the political career of Margaret Thatcher.

We took part in the failed campaign of 2003 to prevent the British prime minister from taking Britain, America's "loyal ally," into the American president's war in Iraq. (The 15 February protest in London was attended by a million or more people, and the war became the subject of a public inquiry, lasting from 2009 to 2015).

Governments may prevent coercion by lesser authorities, such as brutal employers and cruel parents, and where appropriate, anarchists join campaigns for legislation against oppression.

Criminalised in 1960 was the advertising of housing for rent with a "no coloured" requirement. Anarchists were among the activists who went round advising shopkeepers to take such advertisements out of shop windows.

The *What's Wrong with McDonald's* leaflet was about meat as much as about oppression, because its publishers were vegans as well as anarchists. Many anarchists have joined campaigns for

animal welfare. They have joined in hunt saboteur groups to disrupt fox hunting and other blood sports, and in sabotage activities against laboratories using live animals.

Caring for the natural environment, anarchists have also joined groups disrupting the destruction of trees to clear space for motor roads and sabotaging explorations for fracking wells and open-cast coal mines.

Some anarchists have supported campaigns against scientific and technical advances, quite unrelated to oppression or coercion. In the first decade of the twenty-first century, the genetic modification of organisms became practicable and people scared by its unfamiliarity organised campaigns of lies, half-truths and irrelevances against it, which were surprisingly effective in Europe. Experimental crops were destroyed, and anarchists took part in some of these actions.

It is never easy to decide what proportion of participants in a mixed crowd are anarchists, but sometimes there are indications. In 1962, the Campaign for Nuclear Disarmament (CND) invited groups in the Aldermaston march to carry banners, and anarchist group banners appeared in about the same numbers as those of Labour Party branches—roughly ten percent of all marchers, or six to ten thousand individuals.

Anarchists against Nuclear Bombs

Anarchists were included in the Direct Action Committee (DAC), which organised the mass march from London to Aldermaston in 1958, to speak to workers at the atomic weapons factory. We joined the marches in the opposite direction, to speak to politicians, organised by the Campaign for Nuclear Disarmament. We joined the campaign of disruption organised by the Committee of One Hundred, when CND turned from opposing the Bomb, to persuading the anti-Bomb movement to vote Labour (it seems that the CND leaders honestly expected Labour in office to defy the United States and ban the Bomb).

**Great nations plan
for avoiding nuclear war:
Mutually Assured Destruction.
It has worked for 80 years,
and we hope it keeps working.**

In 1963, news leaked out about Regional Seats of Government (RSGs), secret underground installations with walls seven feet thick and with sufficient supplies for several years, where chosen politicians, military service chiefs, and senior civil servants could

shelter if war broke out and the air above Britain was made uninhabitable by nuclear fallout. At the time there were anti-war groups called Artists for Peace, Nurses for Peace, and so on, and an anonymous group called Spies for Peace issued a stencilled typewritten pamphlet describing the RSGs, which was distributed on the Aldermaston March at Easter. Copies were seized by police and soldiers, but the pamphlet was copied and reprinted by all sorts of other groups so it became impossible to trace the originals or identify the originators. The march passed within easy walking distance of RSG-6, at Wargrave near Caterham, and a large number of marchers defied the orders of the CND organisers to visit the site. The then prime minister sensibly put a stop to police action before the matter got out of hand.

Censorious Cruelty

When the *Oxford English Dictionary* was published in 1933, the common words "fuck" and "cunt" were excluded, for fear that Oxford University Press would be prosecuted under the Obscene Publications Act of 1857 and found guilty of rendering the scholarly readers "corrupt and depraved."

Sodomy (anal intercourse) carried the death penalty until 1860, with a stipulation in King's Regulations that sailors at sea were not charged. A law of 1885 prohibited all acts of "gross indecency" among males. Police looking to improve their arrest rates sought opportunities in homosexual gathering places, often inducing one of a pair to turn "Queen's Evidence" and getting the other imprisoned.

The 1950s in Britain was a decade of release from wartime restrictions but also a high time of renewal for the sexual deviants who get their kicks from censorship of other people's pleasures. Holiday-makers at the seaside in the 1930s and service personnel billeted in seaside boarding houses in the 1940s sent home picture postcards, many of them jokes with double-meaning captions such as "Do you like my buns, vicar?" In the 1950s, seaside newsagents'

stocks of rude postcards were seized and burned, under the Obscene Publications Act, by order of seaside town councils.

A pressure group called Clean Up TV was founded in 1964, changed its name to the Viewers and Listeners Association in 1965,

Canes were in constant use in British schools until the 1980s, and not illegal until 1990.

and more recently to Mediawatch in 2007. It declared itself against "violence, profanity, sex, homosexuality and blasphemy," and issued proclamations against "permissiveness."

In those days, and until the 1980s, the beating of children by teachers was an ordinary part of school life, and sex crimes against children were perpetrated by priests, politicians, and entertainers who are now very old or dead. The crimes have now been revealed, and people wonder why it has taken so long. One possible factor is that the crimes were sexual, and in those censorious times, people were reluctant to hear about anything sexual. They pretended not to know, either, that many teachers were sexually aroused by caning pupils.

STOPP, the Society of Teachers Opposed to Physical Punishment, campaigned against the practice, while other teachers argued that it should be retained "as a last resort" for the maintenance of discipline. It was criminalised in 1990, since when spanking is an erotic game, legally played by willing adults, but no longer inflicted on children. Young teachers today are often horrified that such child abuse was considered normal until so recently.

Homosexual and other harmless erotic practices were legalised in 1967 (England and Wales), 1980 (Scotland), 1982 (Northern Ireland), and 1992 (Isle of Man). The Obscene Publications Act of 1959 repealed the Act of 1857.

All these legalisations—the decriminalisation of rude postcards, rude words, pornography, unorthodox sex, and the criminalisation of beating in schools—together constitute a consolidated move towards a less coercive society. Of course it was not achieved by anarchists alone, but it seems right to celebrate it as an anarchist victory.

Don't Vote, It Only Encourages Them

Anarchists are not against majority voting as a method of making a group decision. However, we do not approve of people having coercive power over other people, even if they are been elected by their subjects, like shepherds voted in by sheep. In places ruled by electoral democracies, the government gets in, whoever you vote for.

Why do shepherds care for their sheep ??

Elections take place in "guided democracies" like the old Soviet Union. The ruling party chooses a single list of candidates, one for each constituency, and citizens turn up at polling stations to vote for the pre-chosen representative. In legislative assemblies, the representatives perform the ritual of voting unanimously for whatever is proposed from above. They learn what laws have already been enacted, and then have the job (assuming they are honest) of interceding with officialdom to ensure that their constituents enjoy the rights to which they are legally entitled.

In competitive democracies, such as those of the United Kingdom and the United States, people elected to legislative assemblies vote, and argue, for competing programmes of law. The difference from "guided democracy" is real but should not be exaggerated. Every vote is a vote for the system. Parliament is said to be sovereign, but most of the real power is elsewhere, in capitalist organisations, in the old land-owning class, in the independent military.

When polling organisations first appeared in Britain in the 1950s, asking members of the public how they would vote, a standard question was "How did you vote last time, or were you prevented?" It was assumed that everyone legally entitled to vote would say that they intended to do so and would be ashamed if they did not.

There has been progress, and it has become respectable to declare oneself a nonvoter, or to show contempt for the system by voting for clown parties, such as the Monster Raving Looney Party. But it is not always easy to distinguish between refusing to vote and neglecting to vote. Anarchists, who take the opportunity of an election to explain anarchism, are still called "advocates of apathy" by ignorant commentators.

Many candidates have honest intentions, but to have any hope of being elected, even the most sincere must devote most of their energies to the business of getting elected. Instead of wasting energy on elections, those who wish to change the law may well do better to agitate in a pressure group.

**Beetle wrestling is like
a democratic election.
The competition is amusing to watch
and the result is important (to the beetles).**

Anarchist Publishing

In the 1950s, publishing was very expensive. Printing was still from metal. For text passages, hand setting of text from pre-cast type had largely been replaced by hot metal machines, but the whole process was very expensive. An alternative was the use of stencils set on typewriters, but printing runs for this process are very short.

Small offset lithography, with typewritten texts and drawings photographed onto lithographic plates, became available in the 1960s. Since then, computer typesetting has made printing cheap enough for small anarchist groups and individuals to produce their own papers and leaflets. Technology has moved on, and printing itself is increasingly replaced by electronic communication. Books are still printed, but smaller printed items are often print-outs from publications on computers.

Anarchist book fairs have taken place in London, annually, since 1983. The first few were at Conway Hall, Holborn, then needed a larger venue and moved, most recently (2016) to Park View School, West Green Road. There are many stalls where anarchists sell literature, mostly to each other, joined by other publishers and bookshops seeking anarchist publishers. Anarchist book fairs, either annual or occasional, have also been organised in Glasgow, Bristol, Manchester, Cardiff, and Bradford. Anarchist publishers also have stalls at radical book fairs, socialist book fairs, and other assemblies such as comics fairs and community fairs.

The number and spread of anarchist bookshops is difficult to estimate because, while there are some specialists, there are other shops which advertise themselves to anarchists as "anarchist bookshops" but do not mention anarchism on their websites. If we include them in a list of anarchist bookshops, we should surely include all the bookshops which have shelves or sections labelled "anarchist," including college and general bookshops, as well as clubs and cafés which distribute anarchist work as a sideline.

Direct Action towards Anarchy

The term "direct action" is often used to mean demonstrations which are dangerous, or violent, or illegal. Here, it is used to mean action which has a direct effect in expanding the range of choices for individuals.

In England and Wales, only a licensed lawyer may address the court on behalf of an accused person, but it is permitted for a lay person to be present in court, advising a dependant or litigant what to say and what questions to ask. In recent times in England, the defendant's companion is known as a McKenzie friend, after a legal decision in the 1970s. Some anarchists learn court procedures and act as McKenzie friends, not only for anarchists and people charged with political offences, but for others who need help. Some anarchists also "go bail," acting as sureties for prisoners remanded on bail, sometimes for complete strangers. Anarchists also visit and communicate with prisoners who have few other friends, and provide books for their recreation and comfort.

Anarchists are disgusted by the idea of houses standing empty when people are homeless, and support squatters' movements. In England squatting was made illegal in 2012, rescinding a law dating from 1381 (when disputes arose among people returning for the Crusades), that if a property had been squatted for twenty years, the squatter became the owner. Several anarchist groups organised advice centres for squatters, collecting information on empty buildings and giving legal advice, some of which are still in existence, illegally. One group of anarchists squatted a building owned by a local authority in London, which was scheduled for gutting to prevent squatting, and were jailed, then subsequently hired by the same authority to organise squatting, relieving the housing shortage. In Scotland, squatting was always illegal.

Buildings squatted, or owned, by anarchists have been opened as community resource centres, giving away food or selling it cheaply. Some of these have been taken over by local councils, hiring the organisers as managers. Those which are run by anarchists

can be identified by the fact that they also distribute anarchist literature, but this is not forced on anybody.

Some businesses owned by the workers are anarchist cooperatives, and some communities where assets are held in common were founded by anarchists and in some cases are still run by anarchists. Those who live and work in them not only widen their own choices, but also demonstrate to the world that non-authoritarian ways of life are feasible.

Anarchist action is not just a matter of publicising the idea and advocating revolution. It is also a matter of practical, direct action.

ANARCHIST APPROACHES TO ANARCHISM

The Word "Anarchy"
Errico Malatesta

THE WORD "ANARCHY" WAS UNIVERSALLY USED in the sense of disorder and confusion; and it is to this day used in that sense by the uninformed as well as by political opponents with an interest in distorting the truth.

We will not enter into a philological discussion, since the question is historical and not philological. The common interpretation of the word recognises its true and etymological meaning; but it is a derivative of that meaning due to the prejudiced view that government was a necessary organ of social life, and that consequently a society without government would be at the mercy of disorder, and fluctuate between the unbridled arrogance of some and the blind vengeance of others.

The existence of this prejudice and its influence on the public's definition of the word "anarchy" is easily explained. Man, like all living beings, adapts and accustoms himself to the conditions under which he lives and passes on acquired habits. Thus, having been born and bred in bondage, when the descendants of a long line of slaves started to think, they believed that slavery was an essential condition of life and freedom seemed impossible to them. Similarly, workers who for centuries were obliged, and therefore accustomed, to depend for work, that is bread, on the goodwill of the master, and to see their lives always at the mercy of the owners of the land and of capital, ended by believing that it is the master who feeds them, and ingenuously ask one how would it be possible to live if there were no masters.

So, since it was thought that government was necessary and that without government there could only be disorder and confu-

From *Anarchy*, first published in Italian in 1891, English translation published by Freedom Press (1974).

sion, it was natural and logical that anarchy, which means absence of government, should sound like absence of order. Nor is the phenomenon without parallel in the history of words. In times and in countries where the people believed in the need for government by one man (monarchy) the word republic, which is government by many, was in fact used in the sense of disorder and confusion—and this meaning is still to be found in the popular language of almost all countries.

Change opinion, convince the public that government is not only unnecessary but extremely harmful, and then the word anarchy, just because it means absence of government, will come to mean for everybody: natural order, unity of human needs and the interests of all, complete freedom within complete solidarity.

Those who say, therefore, that the anarchists have badly chosen their name because it is wrongly interpreted by the masses and lends itself to wrong interpretations, are mistaken. The error does not come from the word but from the thing; and the difficulties anarchists face in their propaganda do not depend on the name they have taken, but on the fact that their concept clashes with all the public's long established prejudices on the function of government, or the State as it is also called.

The Ideal of Anarchy
Peter Kropotkin

ANARCHISM (FROM THE GREEK AN- AND *arche*, contrary to authority), the name given to a principle or theory of life and conduct under which society is conceived without government—harmony in such a society being obtained, not by submission to law, or by obedience to any authority, but by free agreements concluded between the various groups, territorial and professional, freely constituted for the sake of production and consumption, as also for the satisfaction of the infinite variety of needs and aspirations of a civilised being.

In a society developed on these lines, the voluntary associations which already now begin to cover all the fields of human activity would take a still greater extension so as to substitute themselves for the State in all its functions. They would represent an interwoven network, composed of an infinite variety of groups and federations of all sizes and degrees, local, regional, national and international—temporary or more or less permanent—for all possible purposes: production, consumption and exchange, communications, sanitary arrangements, education, mutual protection, defence of the territory, and so on; and, on the other side, for the satisfaction of an ever increasing number of scientific, artistic, literary and sociable needs. Moreover, such a society would represent nothing immutable. On the contrary—as is seen in organic life at large—harmony would (it is contended) result from an ever-

This pedantic description of anarchy is from the entry on "Anarchism" in *Encyclopaedia Britannica*, 1910 edition (reprinted in *Anarchism and Anarchist Communism*, Freedom Press, 1987). The word "individualism" has changed its meaning since that time; Kropotkin uses it to mean competitiveness, while today it means the urge towards what Kropotkin calls "individuation."

changing adjustment and readjustment of equilibrium between the multitudes of forces and influences, and this adjustment would be the easier to obtain as none of the forces would enjoy a special protection from the State.

If, it is contended, society were organised on these principles, man would not be limited in the free exercise of his powers in productive work by a capitalist monopoly, maintained by the State; nor would he be limited in the exercise of his will by a fear of punishment, or by obedience towards individuals or metaphysical entities, which both lead to depression of initiative and servility of mind. He would be guided in his actions by his own understanding, which necessarily would bear the impression of a free action and reaction between his own self and the ethical conceptions of his surroundings. Man would thus be enabled to obtain the full development of all his faculties, intellectual, artistic and moral, without being hampered by overwork for the monopolists, or by the servility and inertia of mind of the great number. He would thus be able to reach full *individualisation*, which is not possible either under the present system of *individualism*, or under any system of State Socialism in the so-called *Volksstaat* (Popular State).

The Anarchist writers consider, moreover, that their conception is not a Utopia, constructed on the a priori method, after a few desiderata have been taken as postulates. It is derived, they maintain, from an *analysis of tendencies* that are at work already, even though State Socialism may find a temporary favour with the reformers. The progress of modern technics, which wonderfully simplifies the production of all the necessaries of life; the growing spirit of independence, and the rapid spread of free initiative and free understanding in all branches of activity—including those which formerly were considered as the proper attribution of Church and State—are steadily reinforcing the no-government tendency.

The State organisation, having always been, both in ancient and modern history (Macedonian empire, Roman empire, modern European states grown up on the ruins of autonomous cities),

the instrument for establishing monopolies in favour of the ruling minorities, cannot be made to work for the destruction of these monopolies. The Anarchists consider, therefore, that to hand over to the State all the main sources of economical life—the land, the mines, the railways, banking, insurance, and so on—as also the management of all the main branches of industry, in addition to all the functions already accumulated in its hands (education, State-supported religions, defence of the territory, etc.), would mean to create a new instrument of tyranny. State capitalism would only increase the powers of bureaucracy and capitalism. True progress lies in the direction of decentralisation, both *territorial* and *functional*, in the development of the spirit of local and personal initiative, and of free federation from the simple to the compound, in lieu of the present hierarchy from the centre to the periphery.

In common with most Socialists, the Anarchists recognise that, like all evolution in nature, the slow evolution of society is followed from time to time by periods of accelerated evolution which are called revolutions; and they think that the era of revolutions is not yet closed. Periods of rapid changes will follow the periods of slow evolution, and these periods must be taken advantage of—not for increasing and widening the powers of the State, but for reducing them, through the organisation in every township or commune of the local groups of producers and consumers, as also the regional, and eventually the international federations of these groups.

In virtue of the above principles the Anarchists refuse to be party to the present State organisation and to support it by infusing fresh blood into it.

Anarchist-Communism
Errico Malatesta

THOSE ANARCHISTS WHO CALL THEMSELVES COMMUNISTS (and I am one of them) do so not because they wish to impose their particular way of seeing things on others or because they believe that outside communism there can be no salvation, but because they are convinced, until proved wrong, that the more human beings are joined in brotherhood, and the more closely they cooperate in their efforts for the benefit of all concerned, the greater is the well-being and freedom which each can enjoy. They believe that Man, even if freed from oppression by his fellow men, still remains exposed to the hostile forces of Nature, which he cannot overcome alone, but which, in association with others, can be harnessed and transformed into the means for his own well being. The man who would wish to provide for his material needs by working alone is a slave to his work, as well as not being always sure of producing enough to keep alive. It would be fantastic to think that some anarchists, who call themselves, and indeed are, communists, should desire to live as in a convent, subjected to common rules, uniform meals and clothes, etc.; but it would be equally absurd to think that they should want to do just as they like without taking into account the needs of others or of the right all have to equal freedom. Everybody knows that Kropotkin, for instance, who was one of the most active and eloquent anarchist propagandists of the communist idea was at the same time a staunch defender of the independence of the individual, and passionately desired that everybody should be able to develop and satisfy freely their artistic talents, engage in scientific research, and succeed in establishing a harmonious unity between

From *Pensiero e Volontà*, April 1, 1926, included in *Errico Malatesta: His Life and Ideas* (Freedom Press, 1965).

manual and intellectual activity in order to become human beings in the noblest sense of the word. Furthermore communist-anarchists believe that because of the natural differences in fertility, salubrity and location of the land masses, it would be impossible to ensure equal working conditions for everybody individually and so achieve, if not solidarity, at least, justice. But at the same time they are aware of the immense difficulties in the way of putting into practice that world-wide, free-communism, which they look upon as the ultimate objective of a humanity emancipated and united, without a long period of free development. And for this reason they arrive at conclusions which could be perhaps expressed in the following formula: The achievement of the greatest measure of individualism is in direct ratio to the amount of communism that is possible; that is to say, a maximum of solidarity in order to enjoy a maximum of freedom.

Anarchy as Organisation
Colin Ward

YOU MAY THINK THAT IN DESCRIBING anarchy as *organisation*, I am being deliberately paradoxical. Anarchy you may consider to be, by definition, the *opposite* of organisation. But the word really means something quite different; it means the absence of government, the absence of authority. It is, after all, governments which make and enforce the laws that enable the "haves" to retain control of social assets to the exclusion of the "have-nots." It is, after all, the principle of authority which ensures that people will work for someone else for the greater part of their lives, not because they enjoy or have any control over their work, but because to do so is their only means of livelihood. It is, after all, governments which prepare for and wage war, even though *you* are obliged to suffer the consequences of their going to war.

But is it only governments? The power of a government, even the most absolute dictatorship, depends on the agreement of the governed. Why do people consent to be ruled? It isn't only fear; what have millions of people to fear from a small group of professional politicians and their paid strong-arm men? It is because they subscribe to the same values as their governors. Rulers and ruled alike believe in the principle of authority, of hierarchy, of power. They even feel themselves privileged when, as it happens in a small part of the globe, they can choose between alternative labels on the ruling elites. And yet, in their ordinary lives they keep society going by voluntary association and mutual aid.

Anarchists are people who make a social and political philosophy out of the natural and spontaneous tendency of humans to associate together for their mutual benefit. Anarchism is in fact the

Extract from *Anarchy in Action* (Allen and Unwin, 1973).

name given to the idea that it is possible and desirable for society to organise itself without government. The word comes from the Greek, meaning *without authority*, and ever since the time of the Greeks there have been advocates of anarchy under one name or another. The first person in modern times to evolve a systematic theory of anarchism was William Godwin, soon after the French revolution. A Frenchman, Proudhon, in the mid-nineteenth century developed an anarchist theory of social organisation, of small units federated together but with no central power. He was followed by the Russian revolutionary, Michael Bakunin, the contemporary and adversary of Karl Marx. Marx represented one wing of the socialist movement, concentrating on seizing the power of the state; Bakunin represented the other, seeking the destruction of state power.

The two schools of socialism
Bakunin and Marx

Another Russian, Peter Kropotkin, sought to give scientific foundation to anarchist ideas by demonstrating that mutual aid—voluntary cooperation—is just as strong a tendency in human life as aggression and the urge to dominate. These famous names of

anarchism recur . . . simply because what they wrote speaks, as the Quakers say, to our condition. But there were thousands of other obscure revolutionaries, propagandists and teachers who never wrote books for me to quote but who tried to spread the idea of society without government in Mexico, Russia and Spain. Everywhere they were defeated, and historians wrote that anarchism finally died when Franco's troops entered Barcelona in 1939.

But in Paris in 1968 anarchist flags flew over the Sorbonne, and in the same year they were seen in Brussels, Rome, Mexico City, New York, and even in Canterbury. All of a sudden people were talking about the need for the kind of politics in which ordinary men, women and children decide their own fate and make their own future, about the need for social and political decentralisation, about workers' control of industry, about pupil power in school, about community control of the social services. Anarchism, instead of being a romantic historical by-way, becomes an attitude to human organisation which is more relevant today than ever it seemed in the past.

Freedom and Self-Ownership
Max Stirner

MY FREEDOM IS DIMINISHED IF I cannot impose my will on something outside of myself, whether something inanimate, such as a boulder, or something wilful, such as a government or an individual boss. I diminish my self-ownership if I resign myself to the loss of my freedom, give up, yield, or humiliate myself in loyalty or submission. It is one thing to discontinue an enterprise which is not succeeding, or turn off a wrong road, and quite another thing to surrender. I go round a boulder, until I have enough gunpowder to blast it out of the way. I circumvent the rule of a nation, until I have gathered the strength to overthrow it. I cannot reach the moon, but does that mean I must regard it as "sacred"? I do not surrender to you, I only wait. When I can come at you I will; and meanwhile, if I can find any weakness in you, I will draw it to your attention . . .

From every side resounds the battle cry of "Freedom!" But how many, of those who shout the slogan, understand what authorised freedom or emancipation really means? How few recognise that freedom in the full sense of the word is self-liberation, or that I can only have as much freedom as I take for myself?

What use is it to sheep, that nobody restricts their freedom of speech? They do not wish to say anything but "Baa!" Give someone who is essentially a Muslim, a Jew, or a Christian, permission to speak they please, and they will still speak nothing but narrow-minded nonsense.

The emancipated person is nothing but a person on parole, a dog dragging a piece of chain, a slave in the garment of freedom,

An abridged and amended extract from "Freedom and Self-Ownership," a new translation of "*Eigenheit*," the short middle section of *Der Einzige und sein Eigenthum*, first published in *The University Libertarian* no. 8, 1959.

an ass in a lion's skin. A person who lightens the burden of Jews is better than a Christian who follows church rules, who could not do so without inconsistency, but emancipated Jews are no better off in themselves, only relieved as Jews. The Protestant state can emancipate the Catholics, but if they do not emancipate themselves, they will still be Catholics.

The friends of freedom are offended by selfishness, because in their religious striving for freedom they cannot free themselves from divine "self-abnegation," Egoism upsets libertarians, because an egoist does not care about a thing for the sake of the thing. If he or she cares about anything, it is for her or his own sake. It is egoistic not to ascribe an "absolute" value to anything, but to seek the value of everything in me.

I Became an Anarchist
Emma Goldman

[EMMA, AGED 17, HEARD A LECTURE on the Chicago martyrs.]

At the end of Greie's speech I knew what I had surmised all along: the Chicago men were innocent. They were to be put to death for their ideal. But what was their ideal? Johanna Greie spoke of Parsons, Spies, Lingg, and the others as socialists, but I was ignorant of the real meaning of socialism. What I had heard from the local speakers had impressed me as colourless and mechanistic. On the other hand, the papers called these men anarchists, bomb-throwers. What was anarchism? It was all very puzzling. But I had no time for further contemplation. The people were filing out, and I got up to leave. Greie, the chairman, and a group of friends were still on the platform. As I turned towards them, I saw Greie motioning to me. I was startled, my heart beat violently, my feet felt leaden. When I approached her, she took me by the hand and said: "I never saw a face that reflected such a tumult of emotions as yours. You must be feeling the impending tragedy immensely. Do you know the men?" In a trembling voice I replied: "Unfortunately not, but I do feel the case with every fibre, and when I heard you speak, it seemed to me as if I knew them." She put her hand on my shoulder. "I have a feeling that you will know them better as you learn their ideal, and that you will make their cause your own."

I walked home in a dream. Sister Helena was already asleep, but I had to share my experience with her. I woke her up and recited to her the whole story, giving almost a verbatim account of the speech. I must have been very dramatic, because Helena exclaimed: "The next thing I'll hear about my little sister is that she, too, is a dangerous anarchist."

From *Living My Life* (Alfred Knopf Inc., 1931).

Some weeks later I had occasion to visit a German family I knew. I found them very much excited. Someone from New York had sent them a German paper, *Die Freiheit*, edited by Johann Most. It was filled with news about the events in Chicago. The language fairly took my breath away. . . . It breathed deep hatred of the powers that were preparing the crime in Chicago. I began to read *Die Freiheit* regularly. I sent for the literature advertised in the paper and I devoured every line on anarchism I could get, every word about the men, their lives, their work. I saw a new world opening before me.

The terrible thing everyone feared, yet hoped it would not happen, actually occurred. Extra editions of the Rochester papers carried the news: the Chicago anarchists had been hanged!

Different Views on Organisation
Errico Malatesta

THERE HAVE BEEN ANARCHISTS, AND THERE are still some, who while recognising the need to organise today for propaganda and action, are hostile to all organisations which do not have anarchism as their goal or which do not follow anarchist methods of struggle. To these comrades it seemed that all organised forces for an objective less than radically revolutionary, were forces denied to the revolution. It seems to us instead, and experience has surely already confirmed our view, that their approach would condemn the anarchist movement to a state of perpetual sterility. To make propaganda we must be among the people, and it is in the workers' associations that workers find their comrades and especially those who are most disposed to understand and accept our ideas. But even if it was possible to do as much propaganda as we wished outside the associations, this could not have a noticeable effect on the working masses. Apart from a small number of individuals more educated and capable of abstract thought and theoretical enthusiasms, the worker cannot arrive at anarchism in one leap. To become a convinced anarchist, and not in name only, he must begin to feel the solidarity that joins him to his comrades, and to learn to cooperate with others in the defence of common interests and that, by struggling against the bosses and against the government which supports them, should realise that bosses and governments are useless parasites and that the workers could manage the domestic economy by their own efforts. And when the worker has understood this, he is an anarchist even if he does not call himself such.

Furthermore, to encourage popular organisations of all kinds is the logical consequence of our basic ideas, and should therefore be an integral part of our programme.

From *Errico Malatesta: His Life and Ideas* (Freedom Press, 1965).

An authoritarian party, which aims at capturing power to impose its ideas, has an interest in the people remaining an amorphous mass, unable to act for themselves and therefore always easily dominated. And it follows, logically, that it cannot desire more than that much organisation, and of the kind it needs to attain power: Electoral organisations if it hopes to achieve it by legal means; Military organisation if it relies on violent action.

But we anarchists do not want to *emancipate* the people; we want the people to *emancipate themselves*. We do not believe in the good that comes from above and imposed by force; we want the new way of life to emerge from the body of the people and correspond to the state of their development and advance as they advance. It matters to us therefore that all interests and opinions should find their expression in a conscious organisation and should influence communal life in proportion to their importance.

We have undertaken the task of struggling against existing social organisation, and of overcoming the obstacles to the advent of a new society in which freedom and well-being would be assured to everybody. To achieve this objective we organise ourselves in a party and seek to become as numerous and as strong as possible. But if were only our party that was organised; if the workers were to remain isolated like so many units unconcerned about each other and only linked by the common chain; if we ourselves besides being organised as anarchists in a party, were not as workers organised with other workers, we could achieve nothing at all, or at most, we might be able to impose ourselves, and then it would not be the triumph of anarchy but our triumph. We could then go on calling ourselves anarchists, but in reality we should simply be rulers, and as impotent as all rulers are where the general good is concerned.

The Anarchist Revolution
Errico Malatesta

THE REVOLUTION IS THE CREATION OF new living institutions, new groupings, new social relationships; it is the destruction of privileges and monopolies; it is the new spirit of justice, of brotherhood, of freedom which must renew the whole of social life, raise the moral level and the material conditions of the masses by calling on them to provide, through their direct and conscious action, for their own futures. Revolution is the organisation of all public services by those who work in them in their own interest as well as the public's; Revolution is the destruction of all coercive ties; it is the autonomy of groups, of communes, of regions; Revolution is the free federation brought about by a desire for brotherhood, by individual and collective interests, by the needs of production and defence; Revolution is the constitution of innumerable free groupings based on ideas, wishes, and tastes of all kinds that exist among the people; Revolution is the forming and disbanding of thousands of representative, district, communal, regional, national bodies which, without having any legislative power, serve to make known and to coordinate the desires and interests of people near and far and which act through information, advice and example. Revolution is freedom proved in the crucible of facts—and lasts so long as freedom lasts, that is until others, taking advantage of the weariness that overtakes the masses, of the inevitable disappointments that follow exaggerated hopes, of the probable errors and human faults, succeed in constituting a power, which supported by an army of conscripts or mercenaries, lays down the law, arrests the movement at the point it has reached, and then begins the reaction.

From *Umanità Nova* and *Pensiero e Volontà*, 1920–1924, included in *Errico Malatesta: His Life and Ideas* (Freedom Press, 1965).

The great majority of anarchists, if I am not mistaken, hold the view that anarchy would not be achieved even in a few thousand years, if first one did not create by the revolution, made by a conscious minority, the necessary environment for freedom and well-being. For this reason we want to make the revolution as soon as possible, and to do so we need to take advantage of all positive forces and every favourable situation that arises.

The task of the conscious minority is to use every situation to change the environment in a way that will make possible the education and spiritual elevation of the people, without which there is no real way out.

And since the environment today, which obliges the masses to live in misery, is maintained by violence, we advocate and prepare for violence. That is why we are revolutionaries, not because "we are desperate men, thirsting for revenge and filled with hate."

We are revolutionaries because we believe that only the revolution, the violent revolution, can solve the social question. We believe furthermore that the revolution is an act of will—the will of individuals and of the masses; that it needs for its success certain objective conditions, but that it does not happen of necessity, inevitably, through the single action of economic and political forces.

I told the jury [at my trial] in Milan that I am a revolutionary not only in the philosophical meaning of the word but also in the popular and insurrectionalist sense; and I said so in order to clearly distinguish between my views and those of others who call themselves revolutionaries, but who interpret the world even astronomically so as not to have to bring in the fact of violence, the insurrection, which must open the way to revolutionary achievements. I declared that I had not sought to provoke revolution because at the time there was no need to provoke it; what was urgently needed instead was to bend all our efforts for the revolution to succeed and not lead to new tyrannies; but I insisted that I would have provoked it if the situation demanded then, just as I would in a similar situation in the future.

The Origin of Society
Peter Kropotkin

MOST PHILOSOPHERS OF THE EIGHTEENTH CENTURY had very elementary ideas on the origin of societies.

According to them, in the beginning Mankind lived in small isolated families, and perpetual warfare between them was the normal state of affairs But, one fine day, realising at last the disadvantages of their endless struggles, men decided to socialise. A social contract was concluded among the scattered families who willingly submitted themselves to an authority which—need I say—became the starting point as well as the initiator of all progress. And does one need to add, since we have been told as much at school, that our present governments have so far remained in their noble role as the salt of the earth, the pacifiers and civilisers of the human race?

This idea dominated the eighteenth century, a period in which very little was known about the origins of Man, and one must add that in the hands of the Encyclopaedists and of Rousseau, the idea of the "social contract" became a weapon with which to fight the divine rights of kings. Nevertheless, in spite of the services it may have rendered in the past, this theory must be seen to be false.

The fact is that all animals, with the exception of some carnivores and birds of prey, and some species which are becoming extinct, live in societies. In the struggle for life, it is the gregarious species which have an advantage over those that are not. In every animal classification they are at the top of the ladder and there cannot be the slightest doubt that the first human beings with human attributes were already living in societies.

From *The State, Its Historic Role*, written in French in 1896 and intended for delivery as a lecture.

Man did not create society; society existed before Man.

We now also know—and it has been convincingly demonstrated by anthropology—that the point of departure for mankind was not the family but the clan, the tribe. The patriarchal family as we know it, or as it is depicted in Hebrew traditions, did not appear until very much later. Man spent tens of thousands of years in the clan or tribal phase—let us call it the primitive tribe or, if you wish, the savage tribe—and during this time man had already developed a whole series of institutions, habits and customs much earlier than the institutions of the patriarchal family.

In these tribes, the separate family no more existed than it exists among so many other sociable mammals. Any division within the tribe was mainly between generations, and from a far distant age, going right back to the dawn of the human race, limitations had been imposed to prevent sexual relations between the different generations, which however were allowed between those of the same generation. One can still find traces of that period in some contemporary tribes as well as in the language, customs and superstitions of people of a much higher culture.

The Simplicity of Anarchism
George Nicholson

THE MOST FRIGHTENING ASPECT OF ANARCHISM to the regimented mind is the simplicity of the truths it contains. Whilst society is quite prepared to accept the feasibility of planetary flight, alchemistry and other things within, and beyond, the realms of logic, the simple possibility of man being self-governing and capable of standing on his own feet—without the aid of political or legal crutches—is regarded as something akin to lunacy, or dangerously fanatical to say the least.

The potential horrors of atomic warfare and the possible obliteration of the human race, although here and there invoking a sundry voice of protestation, is presumably nowhere near as terrifying as the prospect of society being freed from political bondage and given independence to organise its own economy by mutual aid and cooperation.

Government provides its own indictment when it so brazenly presumes the helpless imbecility of its subjects, which it regards as a mass of potential lunatics restrained only by the leash of politics and law. It would seem that without the saving grace of politicians, Bedlam itself would be let loose, and that arson, rape, murder and looting would be the order of the day!

One might be impertinent enough to ask why, then, if people are so incapable of self-restraint they should be deemed sufficiently sane to elect others to control them? Why, for instance, do politicians shout, manoeuvre and contrive to get elected by large majorities if those majorities are such potential lunatics?

The anarchist believes that freedom is what its name implies, and he can't conceive how it is possible to be free and at the same time be governed by others—nor can he see how it is possible to help others to

From the anarchist paper *Freedom*, 1955.

be free by sticking bayonets in their bodies or dropping atom bombs on their homes. He considers himself capable of goodness without religion and of dignity without the aid of law, and whilst he is prepared to give freely and of his best in cooperation with others for the commonweal, he takes exception to administering to the selfishness of drones.

He has no faith in the infallibility of politicians, nor in the wisdom of kings. Whilst he repudiates the necessity of law, he concedes the necessity for order: not the kind of order decreed by politicians and enforced threats, but natural order resulting from the harmonious development of mutual respect within society, when once freed from political bondage.

There is something radically wrong, he declares, in a system of society that functions and maintains its existence by the impetus of violence and force. He sees nothing praiseworthy in political society which has recourse to periodic wars, or the need of jails, gallows and bludgeons—and it is because he is aware that these brutal weapons are the instruments of every government and State that he works for their destruction.

To him, freedom is something more than mere political claptrap—it is the quintessence of being and living. It gives focus to the ego's expanding universe, and eclipses the power of ignorance and fear. Given the freedom to assert its inherent qualities, he believes humanity capable of solving its own social problems by the simple application of equity and mutual aid.

Unlike the politician, he does not regard dishonesty, brutality and avariciousness as natural characteristics of human nature, but as the inevitable consequences of coercion and frustration engendered by artificial law, and he believes that these social evils are best eradicated not by greater penalties and further legislation, but by the free development of the latent forces of solidarity and sympathetic understanding which government and law so ruthlessly suppress.

Freedom will be possible when people understand and desire it—for man can only rule where others subserviently obey. Where none obey, none has power to rule.

ANARCHISM AND VIOLENCE

Violence, the Dark Side of Anarchism
Nicolas Walter

ONE OF THE OLDEST AND MOST persistent prejudices about anarchism is that anarchists are above all men of violence. The stereotype of the anarchist with a bomb under his cloak is more than a century old, but it is still going strong. Many anarchists have indeed favoured violence, some have favoured the assassination of public figures, and a few have even favoured terrorism of the population, to help destroy the present system. There is a dark side to anarchism, and there is no point denying it. But it is only one side of anarchism, and a small one. Most anarchists have always opposed any violence except that which is really necessary—the inevitable violence which occurs when the people shake off their rulers and exploiters—though they may have been reluctant to condemn the few anarchists who have resorted to violence for sincere reasons.

The main perpetrators of violence have been those who maintain authority, not those who attack it. The great killers have not been the tragic bomber driven to desperation in southern Europe a century ago, but the military machines of every state in the world throughout history. No anarchist can rival the Blitz and the Bomb, no individual assassin can stand beside Hitler or Stalin. We would encourage workers to seize their factory or peasants to seize their land, and we might break fences or build barricades; but we have no soldiers, no aeroplanes, no police, no prisons, no camps, no firing squads, no gas chambers, no executioners. For anarchists, violence is the extreme example of the use of power by one person against another, the culmination of everything we are against.

From *About Anarchism* (Freedom Press, 1969).

Anarchism and Homicidal Outrage
Charlotte Wilson

> *"The propagandists of Anarchist doctrines will*
> *be treated with the same severity as the actual*
> *perpetrators of outrage."*
> —Telegram from Barcelona, *Times*, Nov. 10 (1893)

IS THE ABOVE QUOTED DECISION OF the Spanish Government a measure for the protection of human life, justified by the peculiar doctrines of Anarchism? Or is it merely one of those senseless and cruel persecutions of new ideas distasteful to the class in power, that may be expected in the ancient home of the Inquisition?

This question must have struck many thoughtful men and women in England, who have heard for the first time of Anarchism as existing in their midst through the recent vituperations of the capitalist press, and certain Conservative members of the House of Commons. And we, the publishing group of the oldest and most widely circulated Communist Anarchist paper in England, wish to meet this question fairly and frankly, and in reply to plainly state our own convictions on the subject.

Human beings have sometimes held beliefs of which murder was the logical and necessary outcome, as, for instance, the Thugs in India, who looked upon the murder of travellers as a religious obligation: is Anarchism such a belief? If it is, then the Spanish people are certainly justified in clearing their country of Anarchists;

Charlotte Wilson was the main founder and first editor of the anarchist paper *Freedom*. This article (signed "The Freedom Group" though it is certain that Charlotte Wilson was the author) was published in 1893 in response to a declaration from the Spanish government. In explaining the difference between anarchism and bomb-throwing, it sets out anarchism clearly, and was therefore issued as a Freedom pamphlet by Wilson's successors in 1909.

even though the perpetration of the Barcelona outrage be never directly traced to them; and the English people will be justified in regarding their Anarchist countrymen as enemies, dangerous in proportion as they are energetic and sincere.

We propose to enquire, firstly, if homicidal outrage is the logical outcome of Anarchist principles; secondly, if such outrage is a necessary method in the practical attempt to introduce Anarchism as a principle of conduct, a transforming agency, into existing society; thirdly, we propose to give our view of homicidal outrage as an actual social phenomenon, the existence of which, whatever be its cause, cannot be disputed.

I. Is homicidal outrage the logical outcome of Anarchist convictions?

The Communist Anarchist looks upon human societies as, essentially, natural groups of individuals, who have grown into association for the sake of mutually aiding one another in self-protection and self-development. Artificially formed Empires, constructed and held together by force, he regards as miserable shams. The societies he recognises are those naturally bound together by real sympathies and common ideas and aims. And in his eyes, the true purpose of every such natural society, whether it be a nation or a federation of nations, a tribe or a village community, is to give to every member of it the largest possible opportunities in life. The object of associating is to increase the opportunities of the individual. One isolated human being is helpless, a hopeless slave to external nature; whereas the limits of what is possible to human beings in free and rational association are as yet unimagined.

Now the Anarchist holds a natural human society good in proportion as it answers what he believes to be its true purpose, and bad in proportion as it departs from that purpose, and instead of enlarging the lives of the individuals composing it crushes and narrows them.

For instance, when in England a comparatively few men claim a right to exclusive possession of the soil, and thereby prevent others from enjoying or using it except upon hard and stinting terms, the Anarchist says that English Society, in so far as it recognises such an arrangement, is bad and fails of its purpose; because such an arrangement instead of enlarging the opportunities for a full human life for everybody, cruelly curtails them for all agricultural workers and many others, and moreover is forced on sufferers against their will, and not arrived at, as all social arrangements ought to be, by mutual agreement.

Such being his view of human societies in general, the Anarchist, of course, endeavours to find out, and make clear to himself and others, the main causes why our own existing society is here and now failing so dismally, in many directions, to fulfil its true function. And he has arrived at the conclusion that these causes of failure are mainly two. First, the unhappy recognition of the authority of man over man as a morally right principle, a thing to be accepted and submitted to, instead of being resisted as essentially evil and wrong. And second, the equally unhappy recognition of the right of property, *i.e.* the right of individuals, who have complied with certain legal formalities, to monopolise material things, whether they are using them or need to use them or not, and whether they have produced them or not. To the Anarchist, the state of the public conscience which permits these two principles of authority and property to hold sway in our social life seems to lie at the root of our miserably desocialised condition; and therefore he is at war with all institutions and all habits which are based on these principles or tend to keep them up. He is not the enemy of society, never of society, only of anti-social abuses.

He is not the enemy of any man or set of men, but of every system and way of acting which presses cruelly upon any human being, and takes away from him any of the chances nature may have allowed him of opportunities equal to those of his fellow men.

Such, in general terms, is the mental attitude of the Anarchist towards Society, and beneath this attitude, at the root of these theories and beliefs lies something deeper: a sense of passionate reverence for human personality; that new-born sense—perhaps the profoundest experience which the ages have hitherto revealed to man—which is yet destined to transform human relations and the human soul; that sense which is still formless and inexpressible to most of us, even those whom it most strongly stirs, and to which Walt Whitman has given the most adequate, and yet a most inadequate and partial voice:

> *Each of us is inevitable,*
> *Each of us is limitless—each of us with his or her right upon the*
> *earth,*
> *Each of us allow'd the eternal purports of the earth,*
> *Each of us here as divinely as any is here.*

Is this an attitude of heart and mind which must logically lead a man to commit homicidal outrage? With such feelings, with such convictions must we not rather attach a peculiar sanctity to human life? And, in fact, the genuine Anarchist looks with sheer horror upon every destruction, every mutilation of a human being, physical or moral. He loathes wars, executions and imprisonments, the grinding down of the worker's whole nature in a dreary round of toil, the sexual and economic slavery of women, the oppression of children, the crippling and poisoning of human nature by the preventable cruelty and injustice of man to man in every shape and form. Certainly, this frame of mind and homicidal outrage cannot stand in the relation of cause and effect.

II. Though Anarchist principles do not in themselves logically lead to the commission of homicidal outrages, do they practically drive the active Anarchist into this course by closing other means of action?

It is true that his convictions close to the conscientious Anarchist one form of social action, just now unfortunately popular, *i.e.* parliamentary agitation.

He cannot conscientiously take part in any sort of government, or try to relieve the cruel pressure upon human lives by means of governmental reforms, because one of the worst possible evils he could do his fellow men would, in his eyes, be to strengthen their idea that the rule of man over man is a right and beneficial thing. For, of course, every well-meant attempt of the men in power to better things tends to confirm people in the belief that to have men in power is, after all, not a social evil. Whereas the aim of the Anarchist is to convince his fellow men that authority is no essential part of human association, but a disruptive element rather, and one to be eliminated, if we would have social union without unjust and unequal social pressure. The current political means of action and protest, therefore, are barred to the Anarchist, by the new-born conception of social relations which is the key note of his creed. On this point he differs from all other Socialists and social reformers.

But is homicide the necessary antithesis of parliamentary agitation? Must the man who looks upon political action, as commonly understood, as useless and worse, necessarily endeavour to spread his views or improve society by outrages upon his fellow-men?

The question is obviously absurd. If one particular way is barred, an infinite variety of other ways are open. The great changes in the world's history, the great advances in human development have not been either set agoing or accomplished by the authority of kings and rulers, but by the initiative of this man and that in making fresh adaptations to changing material conditions, and by the natural and voluntary association of those who saw, or even blindly felt the necessity for a new departure. And now, as always, the great social change which the most callous feel to be at our doors, is springing from the masses, the inmost depths of the nation in revolt against unendurable misery, and fired with a new hope for

better things. We Anarchists have the whole of this vast sphere for our action: the natural and voluntary social life of our countrymen. Not a society founded on principles of voluntary association for any useful purpose whatever, but our place is there. Not a natural human relationship, but it is our work to infuse it with a new spirit. Is not this field wide enough for the zeal of the most fiery propagandist? More particularly in England, at this moment, we find as a field for our endeavours the vast force of the organised labour movement, a force which, rightly applied, could here and now bring about the economic side of the Social Revolution. Not the parliament, not the government, but the organised workmen of England—that minority of the producers who are already organised—*could*, if they would, and if they knew how, put an end to capitalist exploitation, landlord monopoly, to the starvation of the poor, the hopelessness of the unemployed. They have, what government has not, the *power* to do this; they lack only the intelligence to grasp the situation, and the resolution to act. In the face of such a state of things as this, has the propagandist of Socialism, who will none of parliamentary elections, no sphere of action left but homicide? Such a question, we say again, is absurd, and we only raise and answer it here because certain Social Democrats have now and again considered it worth asking.

III. While homicidal outrages are neither a logical outcome of Anarchist principles nor a practical necessity of Anarchist action, they are a social phenomenon which Anarchists and all Social Revolutionaries must be prepared to face.

There is a truism that the man in the street seems always to forget, when he is abusing the Anarchists, or whatever party happens to be his *bête noir* for the moment, as the cause of some outrage just perpetrated. This indisputable fact is that homicidal outrages have, from time immemorial, been the reply of goaded and desperate classes, and goaded and desperate individuals, to wrongs from

their fellow men which they have felt to be intolerable. Such acts are the violent recoil from violence, whether aggressive or repressive; they are the last desperate struggle of outraged and exasperated human nature for breathing space and life. And their cause lies not in any special conviction, but in the depths of that human nature itself. The whole course of history, political and social, is strewn with evidence of this fact. To go no further, take the three most notorious examples of political parties goaded into outrage during the last thirty years: the Mazzinians in Italy, the Fenians in Ireland, and the Terrorists in Russia. Were these people Anarchists? No. Did they all three even hold the same political opinions? No. The Mazzinians were Republicans, the Fenians political separatists, the Russians Social Democrats or Constitutionalists. But all were driven by desperate circumstances into this terrible form of revolt. And when we turn from parties to individuals who have acted in like manner, we stand appalled by the number of human beings goaded and driven by sheer desperation into conduct obviously violently opposed to their social instincts.

Now that Anarchism has become a living force in society, such deeds have been sometimes committed by Anarchists, as well as by others. For no new faith, even the most essentially peaceable and humane the mind of man has as yet accepted, but at its first coming has brought upon earth not peace but a sword; not because of anything violent or anti-social in the doctrine itself; simply because of the ferment any new and creative idea excites in men's minds, whether they accept or reject it. And a conception like Anarchism, which, on the one hand, threatens every vested interest, and, on the other, holds out a vision of a free and noble life to be won by struggle against existing wrongs, is certain to rouse the fiercest opposition, and bring the whole repressive force of ancient evil into violent contact with the tumultuous outburst of a new hope.

Under miserable conditions of life, any vision of the possibility of better things makes the present misery more intolerable, and spurs those who suffer to the most energetic struggles to improve

their lot, and if these struggles only immediately result in sharper misery, the outcome is often sheer desperation. In our present society, for instance, an exploited wage-worker, who catches a glimpse of what work and life might and ought to be, finds the toilsome routine, and the squalor of his existence almost intolerable; and even when he has the resolution and courage to continue steadily working his best, and waiting till the new ideas have so permeated society as to pave the way for better times, the mere fact that he has such ideas, and tries to spread them, brings him into difficulties with his employers. How many thousands of Socialists, and above all of Anarchists have lost work, and even the chance of work, solely on the grounds of their opinions. It is only the specially gifted craftsman who, if he be a zealous propagandist, can hope to retain permanent employment. And what happens to a man with his brains working actively with a ferment of new ideas, with a vision before his eyes of a new hope dawning for toiling and agonising men, with the knowledge that his suffering and that of his fellows in misery is caused not by the cruelty of Fate but by the injustice of other human beings,—what happens to such a man when he sees those dear to him starving, when he himself is starved? Some natures in such a plight, and those by no means the least social or the least sensitive, will become violent, and will even feel that their violence is social and not anti-social, that in striking when and how they can, they are striking not for themselves but for human nature, outraged and despoiled in their persons and in those of their fellow sufferers. And are we, who ourselves are not in this horrible predicament, to stand by and coldly condemn these piteous victims of the Furies and the Fates? Are we to decry as miscreants these human beings, who act often with heroic self-devotion, sacrificing their lives in protest where less social and energetic natures would lie down and grovel in abject submission to injustice and wrong? Are we to join the ignorant and brutal outcry which stigmatises such men as monsters of wickedness, gratuitously running amuck in a harmonious and innocently peaceful society? No! We hate murder

with a hatred that may seem absurdly exaggerated to apologists for Matabele massacres, to callous acquiescers in hangings and bombardments, but we decline, in such cases of homicide or attempted homicide as those of which we are treating, to be guilty of the cruel injustice of flinging the whole responsibility of the deed upon the immediate perpetrator. The guilt of these homicides lies upon every man and woman who, intentionally or by cold indifference, helps to keep up social conditions that drive human beings to despair. The man who flings his whole soul into the attempt, at the cost of his own life, to protest against the wrongs of his fellow men, is a saint compared to the active and passive upholders of cruelty and injustice, even if his protest destroy other lives besides his own. Let him who is without sin in society cast the first stone at such a one.

But we say to no man: "go and do thou likewise."

The man who in ordinary circumstances and in cold blood would commit such deeds is simply a homicidal maniac; nor do we believe they can be justified upon any mere ground of expediency. Least of all do we think that any human being has a right to egg on another person to such a course of action. We accept the phenomena of homicidal outrage as among the most terrible facts of human experience; we endeavour to look such facts full in the face with the understanding of humane justice; and we believe that we are doing our utmost to put an end to them by spreading Anarchist ideas throughout society.

Suppose a street where the drainage system has got thoroughly out of order, and the foulness of the sewer gas is causing serious illness throughout the neighbourhood. The intelligent inhabitants will first of all seek the cause of the illness, and then, having traced it to the condition of the drainage, will insist upon laying the sewer open, investigating the state of the pipes, and where needful, laying new ones. In this process it is very probable indeed that the illness in the neighbourhood may be temporarily increased by the laying open of the foulness within, and that some of those who do the work may be themselves poisoned, or carry the infection

to others. But is that a reason for not opening and repairing the drain? Or would it be fair or rational to say the illness in the neighbourhood was caused by the people who did this work or insisted upon it being done? Yet such is much the attitude of those critics of Anarchism who try to make it appear that we Anarchists are responsible for what is the natural result of the social evils we point out and struggle against.

And how about those Anarchists who use bloodthirsty language? No words can be too strong to denounce the wrongs now inflicted by one human being upon another; but violent language is by no means the same as forcible language, and very often conveys an impression of weakness rather than of strength. Savage talk is often a sort of relief, which half desperate men give to their tortured nerves; sometimes it is the passionate expression of the frenzy of indignation felt by an enthusiastically social nature at the sight of oppression and suffering; or it may be only the harebrained rattle of a fool seeking a sensation; but whatever its nature, our position with regard to it is well expressed by Mr. Auberon Herbert in his letter to the *Westminster Gazette*, Nov. 22: "Of all the miserable, unprofitable, inglorious wars in the world is the war against words. Let men say just what they like. Let them propose to cut every throat and burn every house—if so they like it. We have nothing to do with a man's words or a man's thoughts, except to put against them better words or better thoughts, and so to win in the great moral and intellectual duel that is always going on, and on which all progress depends."

Every man, Anarchist or not, must speak as he thinks fit, but if an Anarchist cannot resist using the language of bloodthirsty revenge, he would do very well to follow the honest example recently set by the editor of the *Commonweal*, and plainly say, "This is not Anarchism."

Government and Homicidal Outrage
Marie Louise Berneri

WHEN THE PORT OF NAPLES IS bombed, it is the thickly populated working class district which surrounds the harbour that suffers most. The bombs do not hit the sumptuous villas of rich Fascists which are scattered along the shores of the bay of Naples; they hit those high storeyed houses so crowded one on top of the other that the streets are no more than dark passages between them; houses where people live four or five to a room.

When German cities are bombed it is not the Nazi elite which suffers. They have deep and comfortable shelters just like the elite in this country. Their families have been evacuated to safe districts or to Switzerland. But the workers cannot escape. The city proletariat, the French, Dutch, Belgian and Scandinavian workers are forced by Himmler's factory Gestapo to go on working in spite of heavy bombing. For them escape is impossible.

Workers in British munition factories and aircraft factories are asked to rejoice at this wholesale destruction from which there is no escaping. Photographs, showing great heaps of ruins, are plastered all over the walls with the caption "This is your work." The ruling class wants them to be proud that they have helped to destroy working class families. For that is what they have done. They have helped their masters to stage massacres compared with which the destruction of Guernica, the bombing of Rotterdam and Warsaw look like playing at war. Such posters should outrage humanity, make them feel sick at the role capitalist society calls upon them to play.

The Italian workers have shown that, in spite of twenty years of fascist oppression, they knew better where their class interests

Part of a 1943 editorial from *War Commentary*, included in *Neither East nor West* (Freedom Press, 1952).

lay. They have refused to be willing tools in the hands of the bosses. They have gone on strike, have sabotaged war industry, have cut telephone wires and disorganized transport. What is the answer of Democratic Britain to their struggle against fascism? Bombing and more bombing. The Allies have asked the Italian people to weaken Mussolini's war machine, and we now take advantage of their own weakness to bomb them to bits.

Our politicians professed to want revolution in Europe to overthrow fascism. But it is now clearer than ever that what they are most afraid of is that fascism should be overthrown by popular revolt. They are terrified of revolution, terrified of "Anarchy." They want to establish "order," and as always they are prepared to wade through rivers of blood to secure their idea of order—order in which the workers accept their lot of poverty and pain with resignation.

How many times in the past have we heard that Anarchism means bombs, that anarchists work for wholesale destruction. How many times has ruling class police repression been instituted because an anarchist has attempted to assassinate a single ruler or reactionary politician? But one single Hamburgizing raid kills more men and women and children than have been killed in the whole of history, true or invented, of anarchist bombs.[1] The anarchist bombs were aimed at tyrants who were responsible for the misery of millions; ruling class bombs just kill thousands of workers indiscriminately.

"Disorder," "Anarchy," cried the bourgeois Press when single-handed resolutes like Sbardelotto, Schirru and Lucetti, tried to kill Mussolini. Now the same capitalists want to rub whole cities off the map of Europe; want to reduce whole populations to star-

1 In an earlier part of the article Berneri had written, "Hamburg, Milan, Genoa, Turin are covered with ruins, their streets heaped with bodies and flowing with blood. 'Hamburgizing' is coming into use as a new term for wholesale destruction of cities, and the mass murder of the their populations through terrorist raids." —ed.

vation, with its resulting scourge of epidemics and disease all over the world. This is the peace and order that they want to bring to the workers of the world with their bombs.

Anarchism and Violence
Vernon Richards

VIOLENCE, CONTRARY TO POPULAR BELIEF, IS not part of the anarchist philosophy. It has repeatedly been pointed out by anarchist thinkers that the revolution can neither be won, nor the anarchist society established and maintained, by armed violence. Recourse to violence, then, is an indication of weakness, not of strength, and the revolution with the greatest possibilities of a successful outcome will undoubtedly be the one in which there is no violence, or in which violence is reduced to a minimum, for such a revolution would indicate the near unanimity of the population in the objectives of the revolution.

The use of violence has been justified both as a principle and as a means to an end; hardly ever, however, by anarchists. At the most anarchists have justified its use as a revolutionary necessity, or *tactic*. The misunderstanding is in part the result of confusion in terms for which the anarchists themselves are responsible. We refer, of course, to those who call themselves pacifist-anarchists, and who thereby imply that those not included in these categories must be violent-anarchists! The fallacy, to our minds, is that of making nonviolence a principle, when in fact it is no more than a tactic. Furthermore, the "nonviolent" advocates fail to make a distinction between violence which is used as a means for imposing the will of a group or class, and that violence which is purely defensive.

There are many ways of changing society. One is by exterminating morally or physically all those who disagree with your way of thinking; the other is by first convincing sufficient people of the rightness of your ideas. Between these two extremes are a number of variations of the first theme but, we submit, there can be

From *Lessons of the Spanish Revolution* (Freedom Press, 1952).

no variations on the second. The self-styled "realists" among the libertarians believed that compromise is morally justified since it produces results.

Violence as a means breeds violence; the cult of personalities as a means breeds dictators—big and small—and servile masses; government—even with the collaboration of socialists and anarchists—breeds more government. Surely then, freedom as a means breeds more freedom, possibly even the Free Society!

To those who say this condemns one to political sterility and the Ivory Tower our reply is that "realism" and their "circumstantialism" invariably lead to disaster. We believe there is something more real, more positive and more revolutionary in resisting war than in participating in it; that it is more civilised and more revolutionary to defend the right of a fascist to live than to support the Tribunals which have the legal powers to shoot him; that it is more realistic to talk to the people from the gutter than from government benches; that in the long run it is more rewarding to influence minds by discussion than to mould them by coercion.

Last, but not least, the question is one of human dignity, of self-respect, and of respect for one's fellows. There are certain things no person can do without ceasing to be human. As anarchists we willingly accept the limitations thus imposed on our actions for, in the words of the old French anarchist Sébastien Faure: "I am aware of the fact that it is not always possible to do what one should do; but I know that there are things that on no account can one ever do."

Anarchism against Nuclear Bombs
Vernon Richards

NUCLEAR WEAPONS AND—WHAT IS MORE IMPORTANT—WAR itself, will not be banned by attempts at persuading governments or taking over governments. Repeated failure of such attempts does not, in itself, prove they are bound to fail forever; but let those who persist in this failed endeavour ask themselves whether they are trying for the logically impossible. Can any government, whatever its political colouring, reconcile such white-blackbirds as authority, privilege, and mass humanity, with freedom, justice, and the individual?

The anarchist road to freedom from nuclear weapons is undoubtedly a slow one, but since decades of anti-nuclear protest through "democratic channels" has led only to the increases in the efficiency and danger of nuclear weapons, we must not feel that our road is any slower than that of the political optimists.

We think there are two kinds of necessary activity. On the one hand any kind of protest is salutary, if only for ourselves. As Marie Louise Berneri put it so simply: "It may be true that our protests will not change the course of events, but we must voice them nevertheless. Workers all over the world rallied to the defence of Sacco and Vanzetti, and who can say their protests were useless?"

On the other hand if the enemy of human emancipation is the State and the government, and we are agreed we cannot easily destroy them by direct assault, then the only alternative left is to eventually destroy them by attrition, by withdrawing power from them as a result of taking over direct responsibility for more and more activities which concern our daily lives. The government are more aware of the dangers herein involved to their power and in-

From "Anarchists against Bombs 1986" in *Freedom: A Hundred Years*, the centenary issue of *Freedom*, October 1986.

dispensability, than are people of the possibilities of real freedom if only they took the plunge, is shown by the massive programmes of the parties and the apathy of the people.

The more we do for ourselves the more we will want to, and know how to, do for ourselves. We must starve the State of initiative. Every radical worthy of the name has shared Jefferson's view that "that government is best which governs least." . . . It is up to us to resist the threat by protest and demonstration, not so much directed towards the government but to draw our fellow citizens' attention to the dangers, showing by our initiative and sense of community that we are more than capable of running our own lives.

What can we do to ban the H-bomb? Very little, friends, until we decide that running our own lives is an important part of life. When we find the time and the patience to run our own lives, we shall have little time or patience for the antics of politicians and power-maniacs, and no energy to waste on making weapons for our own annihilation.

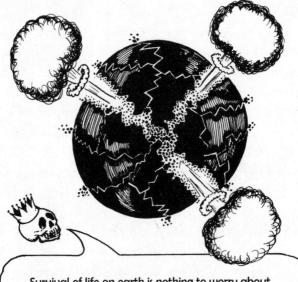

Survival of life on earth is nothing to worry about. 96% of all species were lost in the Permian Extinction, but life recovered in less than ten million years.

ARGUMENTS FOR GOVERNMENT ANSWERED

The Idea of Good Government
Errico Malatesta

NONE CAN JUDGE WITH CERTAINTY WHO is right and who is wrong, who is nearest to the truth, or which is the best way to achieve the greatest good for each and everyone. Freedom coupled with experience, is the only way of discovering the truth and what is best; and there can be no freedom if there is a denial of the freedom to err.

But when one talks of freedom politically, and not philosophically, nobody thinks of the metaphysical bogy of abstract man who exists outside the cosmic and social environment and who, like some god, *could do what he wishes* in the absolute sense of the word.

When one talks of freedom one is speaking of a society in which no one could constrain his fellow beings without meeting with vigorous resistance, in which, above all, nobody could seize and use the collective force to impose his own wishes on others and on the very groups which are the source of power.

Man is not perfect, agreed. But this is one reason more, perhaps the strongest reason, for not giving anyone the means to "put the brakes on individual freedom."

Man is not perfect. But then where will one also find men who are not only good enough to live at peace with others, but also capable of controlling the lives of others in an authoritarian way? And assuming that there were, who would appoint them? Would they impose themselves? But who would protect them from the resistance and the violence of the "criminals"? Or would they be chosen by the "sovereign people," which is considered too ignorant and too wicked to live in peace, but which suddenly acquires all the necessary good qualities when it is a question of asking it to choose its rulers?

From *Umanità Nova*, 1920, included in *Errico Malatesta: His Life and Ideas* (Freedom Press, 1965).

Power Corrupts the Best
Michael Bakunin

THE STATE IS NOTHING ELSE BUT this domination and exploitation regularised and systemised. We shall attempt to demonstrate it by examining the consequence of the government of the masses of the people by a minority, at first as intelligent and as devoted as you like, in an ideal State, founded on a free contract.

Suppose the government to be confined only to the best citizens. At first these citizens are privileged not by right, but by fact. They have been elected by the people because they are the most intelligent, clever, wise, and courageous and devoted. Taken from the mass of the citizens, who are regarded as all equal, they do not yet form a class apart, but a group of men privileged only by nature and for that very reason singled out for election by the people. Their number is necessarily very limited, for in all times and countries the number of men endowed with qualities so remarkable that they automatically command the unanimous respect of a nation is, as experience teaches us, very small. Therefore, under pain of making a bad choice, the people will always be forced to choose its rulers from amongst them.

Here, then, is society divided into two categories, if not yet to say two classes, of which one, composed of the immense majority of the citizens, submits freely to the government of its elected leaders, the other, formed of a small number of privileged natures, recognised and accepted as such by the people, and charged by them to govern them. Dependent on popular election, they are at first distinguished from the mass of the citizens only by the very qualities which recommended them to their choice and are natu-

Written in 1867. From *Marxism, Freedom, and the State*, ed. K.J. Kenafik (Freedom Press, 1950).

rally, the most devoted and useful of all. They do not yet assume to themselves any privilege, any particular right, except that of exercising, insofar as the people wish it, the special functions with which they have been charged. For the rest, by their manner of life, by the conditions and means of their existence, they do not separate themselves in any way from all the others, so that a perfect equality continues to reign among all. Can this equality be long maintained? We claim that it cannot and nothing is easier to prove it.

Nothing is more dangerous for man's private morality than the habit of command. The best man, the most intelligent, disinterested, generous, pure, will infallibly and always be spoiled at this trade. Two sentiments inherent in power never fail to produce this demoralisation; they are: contempt for the masses and the overestimation of one's own merits.

"The masses," a man says to himself, "recognising their incapacity to govern on their own account, have elected me their chief. By that act they have publicly proclaimed their inferiority and my superiority. Among this crowd of men, recognising hardly any equals of myself, I am alone capable of directing public affairs. The people have need of me; they cannot do without my services, while I, on the contrary, can get along all right by myself; they, therefore, must obey me for their own security, and in condescending to command them, I am doing them a good turn."

Is not there something in all that to make a man lose his head and his heart as well, and become mad with pride? It is thus that power and the habit of command become for even the most intelligent and virtuous men, a source of aberration, both intellectual and moral.

Socialism and Freedom
Rudolf Rocker

IN RUSSIA WHERE THE SO-CALLED DICTATORSHIP of the proletariat has ripened into reality, the aspirations of a particular party for political power have prevented any truly socialistic reorganisation of economic life and have forced the country into the slavery of a grinding state-capitalism. The proletarian dictatorship, which naive souls believe is an inevitable transition stage to real Socialism, has today grown into a frightful despotism and a new imperialism, which lags behind the tyranny of Fascist states in nothing. The assertion that the state must continue to exist until society is no longer divided into hostile classes almost sounds, in the light of all historical experience, like a bad joke.

Every type of political power presupposes some particular form of human slavery, for the maintenance of which it is called into being. Just as outwardly, that is, in relation to other states, the state has to create certain artificial antagonisms in order to justify its existence, so also internally the cleavage of society into castes, ranks and classes is an essential condition of its continuance. The development of the Bolshevist bureaucracy in Russia under the alleged dictatorship of the proletariat—which has never been anything but the dictatorship of a small clique over the proletariat and the whole Russian people—is merely a new instance of an old historical experience which has repeated itself countless times. This new ruling class, which today is rapidly growing into a new aristocracy, is set apart from the great masses of Russian peasants and workers just as clearly as are the privileged castes and classes in other countries from the mass of the people. And this situation

Extract from an article on anarchism first published in 1973. Now published with another essay in *Anarchism and Anarcho-syndicalism* (Freedom Press, 1937).

becomes still more unbearable when a despotic state denies to the lower classes the fight to complain of existing conditions, so that any protest is made at the risk of their lives.

But even a far greater degree of economic equality than that which exists in Russia would be no guarantee against political and social oppression. Economic equality alone is not social liberation. It is precisely this which all the schools of authoritarian Socialism have never understood. In the prison, in the cloister, or in the barracks one finds a fairly high degree of economic equality, as all the inmates are provided with the same dwelling, the same food, the same uniform, and the same tasks. The ancient Inca state in Peru and the Jesuit state in Paraguay had brought equal economic provision for every inhabitant to a fixed system, but in spite of this the vilest despotism prevailed there, and the human being was merely the automaton of a higher will on whose decisions he had not the slightest influence. It was not without reason that Proudhon saw in a "Socialism" without freedom the worst form of slavery. The urge for social justice can only develop properly and be effective when it grows out of man's sense of freedom and responsibility, and is based upon it. In other words, *Socialism will be free or it will not be at all.* In its recognition of this fact lies the genuine and profound justification of Anarchism.

Anarchism is not a patent solution for all human problems, no Utopia of a perfect social order (as it has so often been called), since, on principle, it rejects all absolute schemes and concepts. It does not believe in any absolute truth, or in any definite final goals for human development, but in an unlimited perfectibility of social patterns and human living conditions which are always straining after higher forms of expression, and to which, for this reason, one cannot assign any definite terminus nor set any fixed goal. The greatest evil of any form of power is just that it always tries to force the rich diversity of social life into definite forms and adjust it to particular norms. The stronger its supporters feel themselves, the more completely they succeed in bringing every field of social life

into their service, the more crippling is their influence on the operation of all creative cultural forces, the more unwholesomely does it affect the intellectual and social development of power and a dire omen for our times, for it shows with frightful clarity to what a monstrosity Hobbes' *Leviathan* can be developed. It is the perfect triumph of the political machine over mind and body, the rationalization of human thought, feeling and behaviour according to the established rules of the officials and, consequently, the end of all true intellectual culture.

Where the influence of political power on the creative forces in society is reduced to a minimum, there culture thrives the best, for political rulership always strives for uniformity and tends to subject every aspect of social life to its guardianship. And, in this, it finds itself in unescapable contradictions to the creative aspirations of cultural development, which is always on the quest for new forms and fields of social activity, and for which freedom of expression, the many-sidedness and the continual changing of things, are just as vitally necessary as rigid forms, dead rules, and the forcible suppression of ideas are for the conservation of political power. Every successful piece of work stirs the desire for greater perfection and deeper inspiration; each new form becomes the herald of new possibilities of development. But power always tries to keep things as they are, safely anchored to stereotypes. That has been the reason for all revolutions in history. Power operates only destructively, bent always on forcing every manifestation of social life into the straitjacket of its rules. Its intellectual expression is dead dogma, its physical form brute force. And this unintelligence of its objectives sets its stamp on its representatives also, and renders them often stupid and brutal, even when they were originally endowed with the best talents. One who is constantly striving to force everything into a mechanical order at last becomes a machine himself and loses all human feelings.

It was from this understanding that modern Anarchism was born and draws its moral force. Only freedom can inspire men to

great things and bring about intellectual and social transformations. The art of ruling men has never been the art of educating and inspiring them to a new shaping of their lives. Dreary compulsion has at its command only lifeless drill, which smothers any vital initiative at its birth and brings forth only subjects, not free man. Freedom is the very essence of life, the impelling force in all intellectual and social development, the creator of every new outlook in the future of mankind. The liberation of man from economic exploitation and from intellectual, social and political oppression, which finds its highest expression in the philosophy of Anarchism, is the first prerequisite for the revolution of a higher social culture and a new humanity.

Anarchism and Authoritarian Socialism
Errico Malatesta

IT IS TRUE THAT ANARCHISTS AND socialists have always profoundly disagreed in their concepts of historic evolution and the revolutionary crises that this evolution creates, and consequently they have hardly ever been in agreement on the means to adopt, or the opportunities that have existed from time to time to open up the way towards human emancipation.

But this is only an incidental and minor disagreement. There have always been socialists who have been in a hurry, just as there are also anarchists who want to advance with leaden feet, and even some who do not believe at all in revolution. The important, fundamental dissension is quite another: socialists are authoritarians, anarchists are libertarians.

Socialists want power, whether by peaceful means or by force is of no consequence to them, and once in office, wish to impose their programme on the people by dictatorial or democratic means. Anarchists instead maintain, that government cannot be other than harmful, and by its nature it defends either an existing privileged class or creates a new one; and instead of aspiring to take the place of the existing government anarchists seek to destroy every organism which empowers some to impose their own ideas and interests on others, for they want to free the way for development towards better forms of human fellowship which will emerge from experience, by everybody being free and having, of course, the economic means to make freedom possible as well as a reality.

Various publications, 1897–1923, included in *Errico Malatesta: His Life and Ideas* (Freedom Press, 1965).

It seems unbelievable that even today, after what has happened and is happening in Russia [1921], there are still people who imagine that the differences between socialists and anarchists is only that of wanting revolution slowly or in a hurry.

Social democrats start off from the principle that the State, government, is none other than the political organ of the dominant class. In a capitalistic society, they say, the State necessarily serves the interests of the capitalists and ensures for them the right to exploit the workers; but that in a socialist society, when private property were to be abolished, and with the destruction of economic privilege class distinctions would disappear, then the State would represent everybody and become the impartial organ representing the social interests of all members of society.

Here a difficulty immediately arises. If it be true that Government is necessarily, and always, the instrument of those who possess the means of production, how can this miracle of a socialist government arising in the middle of a capitalist regime with the aim of abolishing capitalism, come about? Will it be as Marx and Blanqui wished by means of a dictatorship imposed by revolutionary means, by a *coup de force*, which by revolution decrees and imposes the confiscation of private property in favour of the state, as representative of the interests of the collectivity? Or will it be, as apparently all Marxists, and most modern Blanquists believe, by means of a socialist majority elected to Parliament by universal suffrage? Will one proceed in one step to the expropriation of the ruling class by the economically subjected class, or will one proceed gradually in obliging property owners and capitalists to allow themselves to be deprived of all their privileges a bit at a time?

All this seems strangely in contradiction with the theory of "historic materialism" which is a fundamental dogma for Marxists.

"Communism is the road that leads in the direction of anarchism." This is the theory of the Bolsheviks; the theory of Marxists and authoritarian socialists of all schools. All recognise that anarchy is a sublime ideal, that it is the goal towards which mankind is,

or should be, moving, but they all want to become the government, to oblige the people to take the right road. Anarchists say instead, that anarchy is the way that leads to communism or elsewhere.

To achieve communism before anarchy, that is before having conquered complete political and economic liberty, would mean (as it has meant in Russia) stabilising the most hateful tyranny, to the point where people long for the bourgeois regime, and to return later (as will happen in Russia) to a capitalistic system as a result of the impossibility of organising social life which is bearable and as a reaction of the spirit of liberty which is not a privilege of the "latin spirit" as the *Communist* foolishly accuses me of saying, but a necessity of the human spirit for action in Russia no less than in Italy.

However much we detest the democratic lie, which in the name of the "people" oppresses the people in the interests of a class, we detest even more, if that is possible, the dictatorship which, in the name of the "proletariat" places all the strength and the very lives of the workers in the hands of the creatures of a so-called communist party, who will perpetuate their power and in the end reconstruct the capitalist system for their own advantage.

When F. Engels, perhaps to counter anarchist criticisms, said that once classes disappear the State as such has no *raison d'être* and transforms itself from a government over men into an administration of things, he was merely playing with words. Whoever has power over things has power over men; whoever governs production also governs the producers; who determines consumption is master over the consumer.

This is the question; either things are administered on the basis of free agreement among the interested parties, and this is anarchy; or they are administered according to laws made by administrators and this is government, it is the State, and inevitably it turns out to be tyrannical.

It is not a question of the good intentions or the good will of this or that man, but of the inevitability of the situation, and of

the tendencies which man generally develops in given circumstances.

What is the true basis of the differences between anarchists and State communists? We are for freedom, for the widest and the most complete freedom of thought, organisation and action. We are for the freedom of all, and it is therefore obvious, and not necessary to continually say so, that everyone in exercising his right to freedom must respect the equal freedom of everybody else; otherwise there is oppression on one side and the right to resist and to rebel on the other.

But State communists, to an even greater extent than all other authoritarians, are incapable of conceiving freedom and of respecting for all human beings the dignity that they expect, or should expect, from others. If one speaks to them of freedom they immediately accuse one of wanting to respect, or at least tolerate, the freedom to oppress and exploit one's fellow beings. And if you say that you reject violence when it exceeds the limits imposed by the needs of defence, they accuse you of pacifism, without understanding that violence is the whole essence of authoritarianism, just as the repudiation of violence is the whole essence of anarchism.

Anarchism and Property
Errico Malatesta

OUR OPPONENTS, INTERESTED DEFENDERS OF THE existing system are in the habit of saying, to justify the right to private property, that it is the condition and guarantee of freedom.

And we agree with them. Are we not always repeating that he who is poor is a slave? Then why are they our opponents?

The reason is clear and is that in fact the property they defend is capitalist property, that is, property which allows some to live by the work of others and which therefore presupposes a class of dispossessed, propertyless people, obliged to sell their labour power to the property-owners for less than its value.

The principal reason for the bad exploitation of nature, and of the miseries of the workers, of the antagonisms and the social struggles, is the *right to property* which confers on the owners of the land, the raw materials and of all the means of production, the possibility to exploit the labour of others and to organise production not for the well-being of all, but in order to guarantee a maximum profit for the owners of property. It is necessary therefore to abolish property.

The principle for which we must fight and on which we cannot compromise, whether we win or lose, is that all should possess the means of production in order to work without subjection to capitalist exploitation. The abolition of individual property, in the literal sense of the word, will come, if it comes, by the force of circumstances, by the demonstrable advantages of communistic management, and by the growing spirit of brotherhood. But what has to be destroyed at once, even with violence if necessary, is *capitalistic*

From *Umanità Nova* and *Il Risveglio*, 1921–1929, included in *Errico Malatesta: His Life and Ideas* (Freedom Press, 1965).

property, that is, the fact that a few control the natural wealth and the instruments of production and can thus oblige others to work for them.

Imposed communism would be the most detestable tyranny that the human mind could conceive. And free and voluntary communism is ironical if one has not the possibility to live in a different regime—collectivist, mutualist, individualist—as one wishes, always on condition that there is no oppression or exploitation of others.

Free then is the peasant to cultivate his piece of land, alone if he wishes; free is the shoemaker to remain at his last or the blacksmith in his small forge. It remains to be seen whether not being able to obtain assistance or people to exploit—and he would find none because nobody, having a right to the means of production and being free to work on his own or as an equal with others in the large organisations of production would want to be exploited by a small employer—I was saying, it remains to be seen whether these isolated workers would not find it more convenient to combine with others and voluntarily join one of the existing communities.

The destruction of title deeds would not harm the independent worker whose real title is possession and the work done.

What we are concerned with is the destruction of the titles of the proprietors who exploit the labour of others, expropriating them in fact in order to put the land, houses, factories and all the means of production at the disposal of those who do the work.

It goes without saying that former owners would only have to take part in production in whatever way they can, to be considered equals with all other workers.

Will property [in the revolutionary period] have to be individual or collective? And will the collective holding the undivided goods be the local group, the functional group, the group based on political affinity, the family group—will it comprise all the inhabitants of a nation *en bloc* and eventually all humanity?

What forms will production and exchange assume? Will it be the triumph of *communism* (production in association and free consumption for all), or *collectivism* (production in common and the distribution of goods on the basis of the work done by each individual), or *individualism* (to each the individual ownership of the means of production and the enjoyment of the full product of his labour), or other composite forms that individual interest and social instinct, illuminated by experience, will suggest?

Probably every possible form of possession and utilisation of the means of production and always of distribution of produce will be tried out at the same time in one or many regions, and they will combine to be modified in various ways until experience will indicate which form, or forms, is or are, the most suitable.

In the meantime, the need for not interrupting production, and the impossibility of suspending consumption of the necessities of life, will make it necessary to take decisions for the continuation of daily life at the same time as expropriation proceeds. One will have to do the best one can, and so long as one prevents the constitution and consolidation of new privilege, there will be time to find the best solutions.

I call myself a communist, because communism, it seems to me, is the ideal to which mankind will aspire as love between men, and an abundance of production, will free them from the fear of hunger and will thus destroy the major obstacle to brotherhood between them. But really, even more than the practical forms of organisation which must inevitably be adjusted according to the circumstances, and will always be in a constant state of change, what is important is the spirit which informs those organisations, and the method used to bring them about; what I believe important is that they should be guided by the spirit of justice and the desire of the general good, and that they should always achieve their objectives through freedom and voluntarily. If freedom and a spirit of brotherhood truly exist, all solutions aim at the same objective of emancipation and human enlightenment and will end by being

reconciled by fusion. If, on the contrary, there is no freedom and the desire for the good of all is lacking, all forms of organisation can result in injustice, exploitation, and despotism.

What Is Property?
Pierre-Joseph Proudhon

IF I WERE ASKED TO ANSWER the following question: *What is slavery?* and I should answer in one word, *It is murder*, my meaning would be understood at once. No extended argument would be required to show that the power to take from a man his thought, his will, his personality, is a power of life and death; and that to enslave a man is to kill him. Why, then, to this other question: *What is property?* may I not likewise answer, *It is robbery*, without the certainty of being misunderstood; the second proposition being no other than a transformation of the first.

To be governed is to be watched over, inspected, spied on, directed, legislated at, regulated, docketed, indoctrinated, preached at, controlled, assessed, weighed, censored, ordered about, by men who have neither the right, nor the knowledge, nor the virtue. . . . To be governed is to be at every operation, at every transaction, noted, registered, enrolled, taxed, stamped, measured, numbered, assessed, licensed, authorized, admonished, forbidden, reformed, corrected, punished. It is, under the pretext of public utility, and in the name of the general interest, to be placed under contribution, trained, ransomed, exploited, monopolized, extorted, squeezed, mystified, robbed; then, at the slightest resistance, the first word of complaint, to be repressed, fined, despised, harassed, tracked, abused, clubbed, disarmed, choked, imprisoned, judged, condemned, shot, deported, sacrificed, sold, betrayed; and, to crown all, mocked, ridiculed, outraged, dishonoured. That is government; that is its justice; that is its morality.

From *What Is Property?* (1840), translated by Benjamin R. Tucker 1890, and *The General Idea of the Revolution* (1851); quoted by James Joll in *The Anarchists* (Little, Brown and Company, 1964).

The Authority of Government
William Godwin

AUTHORITY IN THE LAST OF THE three senses alluded to is where a man, in issuing his precept, does not deliver that which may be neglected with impunity; but his requisition is attended with a sanction, and the violation of it will be followed with a penalty. This is the species of authority which properly connects itself with the idea of government. It is a violation of political justice to confound the authority which depends upon force, with the authority which arises from reverence and esteem; the modification of my conduct which might be due in the case of wild beast, with the modification which is due to superior wisdom. These kinds of authority may happen to vest in the same person; but they are altogether distinct and independent.

To a government, therefore, that talked to us of deference to political authority, and honour to be rendered to our superiors, our answer should be: "It is yours to shackle the body, and restrain our external actions; that is a restraint we understand. Announce your penalties; and we will make our election of submission or suffering. But do not seek to enslave our minds. Exhibit your force in its plainest form, for that is your province; but seek not to inveigle and mislead us. Obedience and external submission is all you are entitled to claim; you can have no right to extort our deference, and command us not to see, and disapprove of, your errors."

From *An Inquiry Concerning Political Justice* (1793), included in *The Anarchist Writings of William Godwin*, ed. Peter Marshall (Freedom Press, 1986).

THE RELEVANCE
OF ANARCHISM

Is Anarchy Possible?

Alexander Berkman

"It might be possible," you say, "if we could do without government. But can we?"

Perhaps we can best answer your question by examining your own life.

What role does the government play in your existence? Does it help you live? Does it feed, clothe and shelter you? Do you need it to help you work or play? If you are ill, do you call the physician or the policeman? Can the government give you greater ability than nature endowed you with? Can it save you from sickness, old age, or death?

Consider your daily life and you will find that in reality the government is no factor in it all except when it begins to interfere in your affairs, when it compels you to do certain things or prohibits you from doing others. It forces you, for instance, to pay taxes and support it, whether you want to or not. It makes you don a uniform and join the army. It invades your personal life, orders you about, coerces you, prescribes your behaviour, and generally treats you as it pleases. It tells you even what you must believe and punishes you for thinking and acting otherwise. It directs you what to eat and drink, and imprisons or shoots you for disobeying. It commands you and dominates every step of your life. It treats you as a bad boy, as an *irresponsible* child who needs the strong hand of a guardian, but if you disobey it holds you *responsible*, nevertheless.

Is it not peculiar that most people imagine we could not do without government, when in fact our real life has no connection with it whatever, no need of it, and is only interfered with where law and government step in?

From *ABC of Anarchism* (Freedom Press, 1942), first published 1927.

"But security and public order," you object, "could we have that without law and government? Who will protect us against the criminal?"

The truth is what is called "law and order" is really the worst disorder. What little order and peace we do have is due to the good commonsense of the joint efforts of the people, mostly in spite of the government. Do you need government to tell you not to step in front of a moving automobile? Do you need it to order you not to jump off the Brooklyn Bridge or from the Eiffel Tower?

Man is a social being: he cannot exist alone; he lives in communities or societies. Mutual need and common interests result in certain arrangements to afford us security and comfort. Such co-working is free, voluntary; it needs no compulsion by any government. You join a sporting club or a singing society because your inclinations lie that way, and you cooperate with the other members without any one coercing you. The man of science, the writer, the artist, and the inventor seek their own kind of inspiration and mutual work. Their impulses and needs are their best urge; the interference of any government or authority can only hinder their efforts.

All through life you will find that the needs and inclinations of people make for association, for mutual protection and help. That is the difference between managing things and governing men; between doing something from free choice and being compelled. It is the difference between liberty and constraint, between anarchism and government, because anarchism means voluntary cooperation instead of forced participation. It means harmony and order in place of interference and disorder.

"But who will protect us against crime and criminals?" you demand. Rather ask yourself whether government really protects us against them. Does not government itself create and uphold conditions which make for crime? Does not the invasion and violence upon which all governments rest cultivate the spirit of intolerance and persecution, of hatred and more violence? Does not

crime increase with the growth of poverty and injustice fostered by government? Is not government itself the greatest injustice and crime?

Crime is the result of economic conditions, of social inequality, of wrongs and evils of which government and monopoly are parents. Government and law can only punish the criminal. They neither cure nor prevent crime. The only real cure for crime is to abolish its causes, and this the government can never do because it is there to preserve those very causes. Crime can be eliminated only by doing away with the conditions that create it. Government cannot do it.

Anarchism means to do away with those conditions. Crimes resulting from government, from its oppression and injustice, from inequality and poverty, will disappear under anarchy. These constitute by far the greatest percentage of crime.

The truth is, present life is impractical, complex and confused, and not satisfactory from any point of view. That is why there is so much misery and discontent. The worker is not satisfied; nor is the master happy in his constant anxiety over "bad times" involving loss of property and power. The spectre of fear for tomorrow dogs the steps of poor and rich alike.

Certainly the worker has nothing to lose by a change from government and capitalism to a condition of no government, of anarchy.

The middle classes are almost as uncertain of their existence as the workers. They are dependent upon the goodwill of the manufacturer and wholesaler, of the large combines of industry and capital, and they are always in danger of bankruptcy and ruin.

Even the big capitalist has little to lose by the changing of the present-day system to one of anarchy, for under the latter every one would be assured of his living and comfort; the fear of competition would be eliminated with the abolition of private ownership. Every one would have full and unhindered opportunity to live and enjoy his life to the utmost of his capacity.

Add to this the consciousness of peace and harmony; the feeling that comes with freedom from financial or material worries; the realisation that you are in a friendly world with no envy or business rivalry to disturb your mind; in a world of brothers; in an atmosphere of liberty and general welfare.

It is almost impossible to conceive of the wonderful opportunities which would open up to man in a society of communist anarchism. The scientist could fully devote himself to his beloved pursuits, without being harassed about his daily bread. The inventor would find every facility at his disposal to benefit humanity by his discoveries and inventions. The writer, the poet, the artist—all would rise on the wings of liberty and social harmony to greater heights of attainment.

DOING WHAT YOU LIKE

Precise Description of Anarchy
Errico Malatesta

SOME DEMAND TO BE TOLD IN detail how a liberated society would be organised, and there follows a whole series of questions which might be interesting if we were studying the problems of anarchy in theory, but which are useless, or absurd, or ridiculous, if we are expected to provide definitive solutions. What methods will be used to teach children? How will production be organised? Will there still be large cities, or will the population be evenly distributed over the surface of the earth? Supposing the inhabitants of Siberia should want to spend the winter in Nice? Who will empty the privies? Will sick people be treated at home or in hospital? Who will establish the railway timetable? What will be done if a train driver has a stomach ache while the train is moving? . . . And so on, to the point of assuming that we have all the knowledge and experience of the unknown future, and that in the name of anarchy we should prescribe for future generation what time they should go to bed, and on what days they must cut their toenails.

If our readers expect a reply from us to these questions, which is more than our personal opinion at this moment, it means that we have failed to explain to them what anarchism is about.

We are no more prophets than anyone else, and if we claimed to be giving an official solution to the problems of daily life of a future society, we would be declaring ourselves the government, and prescribing a universal code for present and future generations.

From *Anarchy* (Freedom Press, 1974), abridged and amended; first published 1892.

Crime in an Anarchy
William Morris

"WELL," SAID I, "THAT IS UNDERSTOOD, and I agree with it; but how about crimes of violence? would not their occurrence (and you admit that they occur) make criminal law necessary?"

Said he: "In your sense of the word, we have no criminal law either. Let us look at the matter closer, and see whence crimes of violence spring. By far the greater part of these in past days were the result of the laws of private property, which forbade the satisfaction of their natural desires to all but a privileged few, and of the general visible coercion which came of these laws. All *that* cause of violent crime is gone. Again, many violent acts came from the artificial perversion of the sexual passions, which caused overweening jealousy and the like miseries. Now, when you look carefully into these, you will find that what lay at the bottom of them was mostly the idea (a law-made idea) of the woman being the property of man, whether he were husband, father, brother, or what not. *That* idea has of course vanished with private property, as well as certain follies about the 'ruin' of women for following their natural desires in an illegal way, which of course was a convention caused by the laws of private property.

"Another cognate cause of crimes of violence was the family tyranny, which was the subject of so many novels and stories of the past, and which once more was the result of private property. Of course that is all ended, since families are held together by no bond of coercion, legal or social, but by mutual liking and affection, and everybody is free to come and go as he or she pleases. Furthermore, our standards of honour and public estimation are very different from the old ones; success in besting our neighbours is a road to re-

From *News from Nowhere* (Roberts Brothers, 1890).

nown now closed, let us hope for ever. Each man is free to exercise his special faculty to the utmost, and every one encourages him in so doing. So that we have got rid of the scowling envy, coupled by the poets with hatred, and surely with good reason; heaps of unhappiness and ill-blood were caused by it, which with irritable and passionate men—*i.e.*, energetic and active men—often led to violence."

I laughed, and said: "So that you now withdraw your admission, and say that there is no violence amongst you?"

"No," said he, "I withdraw nothing; as I told you, such things will happen. Hot blood will err sometimes. A man may strike another, and the stricken strike back again, and the result be a homicide, to put it at the worst. But what then? Shall we the neighbours make it worse still? Shall we think so poorly of each other as to suppose that the slain man calls on us to revenge him, when we *know* that if he had been maimed, he would, when in cold blood and able to weigh all the circumstances, have forgiven his maimer? Or will the death of the slayer bring the slain man to life again and cure the unhappiness his loss has caused?"

"Yes," I said, "but consider, must not the safety of society be safeguarded by some punishment?"

"There, neighbour!" said the old man, with some exultation. "You have hit the mark. That *punishment* of which men used to talk so wisely and act so foolishly, what was it but the expression of their fear? And they had need to fear, since *they—i.e.*, the rulers of society—were dwelling like an armed band in a hostile country. But we who live amongst our friends need neither fear nor punish. Surely if we, in dread of an occasional rare homicide, an occasional rough blow, were solemnly and legally to commit homicide, we could only be a society of ferocious cowards. Don't you think so, neighbour?"

"Yes, I do, when I come to think of it from that side," said I.

"Yet you must understand," said the old man, "that when any violence is committed, we expect the transgressor to make any atonement possible to him, and he himself expects it. But again,

think if the destruction or serious injury of a man momentarily overcome by wrath or folly can be any atonement to the commonwealth? Surely it can only be an additional injury to it."

Said I: "But suppose the man has a habit of violence, kills a man a year, for instance?"

"Such a thing is unknown," said he. "In a society where there is no punishment to evade, no law to triumph over, remorse will certainly follow transgression."

"And lesser outbreaks of violence," said I, "how do you deal with them? for hitherto we have been talking of great tragedies, I suppose?"

Said Hammond: "If the ill-doer is not sick or mad (in which case he must be restrained till his sickness or madness is cured) it is clear that grief and humiliation must follow the ill-deed; and society in general will make that pretty clear to the ill-doer if he should chance to be dull to it; and again, some kind of atonement will follow,—at the least, an open acknowledgment of the grief and humiliation. Is it so hard to say, I ask your pardon, neighbour?— Well, sometimes it is hard—and let it be."

"You think that enough?" said I.

"Yes," said he, "and moreover it is all that we *can* do. If in addition we torture the man, we turn his grief into anger, and the humiliation he would otherwise feel for *his* wrong-doing is swallowed up by a hope of revenge for *our* wrong-doing to him. He has paid the legal penalty remitted before he said 'Go and sin no more.' Let alone that in a society of equals you will not find any one to play the part of torturer or jailer, though many to act as nurse or doctor."

"So," said I, "you consider crime a mere spasmodic disease, which requires no body of criminal law to deal with it?"

"Pretty much so," said he; "and since, as I have told you, we are a healthy people generally, so we are not likely to be much troubled with *this* disease."

Anarchism and Psychology
Tony Gibson

TODAY MOST PEOPLE CALLING THEMSELVES PSYCHOLOGISTS (and recognised as such by their professional organisation) would agree that what psychology is about is the study of behaviour.

Can psychology be used for anti-social ends? Yes of course it can—and is. Given a proper understanding of the mechanisms of human behaviour, people can be efficiently brainwashed. But this is not really an argument against psychology. All science gives power. The same sorts of science can be used to raise food production or to lay countries waste; knowledge of human physiology can be used to cure disease or poison people with nerve gases. Anarchism is not anti-knowledge, but opposed to the abuse of that knowledge by power groups.

Now the ordinary layman feels that he can understand what science is about in matters of physics and chemistry, but he is rather uneasy about scientific psychology. This fear is a hangover from religion. He fears that the brutal behaviourist will disregard his tender psyche, do horrible things to his shy unconscious, and somehow undermine his human dignity. Many would rather trust the blandishments of such ambiguous characters as the existential psychoanalysts who practise all of the worst faults of psychiatry under the guise of "anti-psychiatry." They, like a very similar mob, the Scientologists, make a bid for influence by wrapping everything they claim in such vague and woolly jargon, and appeal to every high-sounding principle and libertarian exhortation, that their meaning is suitably obscure. They are the modern equivalent of

From *Freedom*, 18 July 1970, an article from a controversy in which Tony, a behaviourist, debated with advocates of psychoanalysis, anti-psychiatry, and orgone theory. Anarchism does not imply adherence to any particular school of psychology.

the idealist philosophers against whom Bakunin railed. They are the purveyors of hocus pocus who are stepping into the places left by the priests of the dying Christian religion.

As a scientist I have a natural antipathy to hocus pocus whether it is purveyed by Aleister Crowley, Ronnie Laing, or Ronnie Hubbard. Also, in my stiffnecked and prejudiced way, I have a contempt for those who become dupes because they are too feeble to question the authority of anyone who sets up to be a Master . . .

Behaviourist psychology is essentially radical and egalitarian. Popularisers like Eysenck have shown that everyone can come to grips with the problems of psychology. We think with our heads, not with our blood as the late Adolf Hitler enjoined us to do.

What we are up against is ignorance and fear. I trust and value the manipulations in which my dentist is skilled. Likewise I value the manipulations of other specialists—even those who have "manipulated" my mind by teaching me things I wanted to learn. But I am my own owner, in Stirner's words, and it is up to every man to own himself. If we own ourselves we will not be frightened of the bogey of the behaviourist psychologist. Rather we should be chary of the claims of the guru who promises some sort of spiritual salvation if we will only trust to his analysing us or processing us, and lead us to a Higher Reality.

Ill-Health and Poverty
John Hewetson

POVERTY IS STILL THE LOT OF millions, and attendant upon it come sickness, lowered health, and premature death. The facts are indescribably grim. Yet if one permits one's imagination to fill in the details, to try and picture the amount of pain and misery and frustration caused by ill-health, one's anger at the society which creates and permits such a volume of suffering is almost stifling.

Nevertheless, the situation has its favourable aspect. Anger is called forth because the misery and ill-health caused by poverty are preventable. "If preventable," one can say, "Why not prevented?" For with the resources which men can call on today, there is abundance in the world for everyone, and poverty could be completely eradicated. With its disappearance, the vast body of human sickness would also disappear, and the sheer weight of the problem of ill-health which today preoccupies the intricate system of hospitals and clinics and insurance schemes would be reduced to a mere fraction of its present proportions. The problem of ill-health therefore is not finally insoluble. It will be shown, however, in the following pages [of Hewetson's pamphlet] that the problem cannot be solved within the structure of capitalist society with its rigid division into few rich and many poor. The important fact to grasp is that the problem of ill-health will not be solved by any measures which fail to solve the problem of poverty.

From the first chapter of *Ill-Health, Poverty and the State* (Freedom Press, 1946).

Small Steps in the Direction of Anarchy

Colin Ward

As ALEXANDER HERZEN PUT IT OVER a century ago: "A goal which is infinitely remote is not a goal at all, it is a deception. A goal must be closer—at the very least the labourer's wage or pleasure in the work performed. Each epoch, each generation, each life has had, and has, its own experience, and the end of each generation must be itself."

The choice between libertarian and authoritarian solutions is not a once-and-for-all cataclysmic struggle, it is a series of running engagements, most of them never concluded, which occur, and have occurred, throughout history. Every human society, except the most totalitarian of utopias or anti-utopias, is a plural society with large areas which are not in conformity with the officially imposed or declared values. An example of this can be seen in the alleged division of the world into capitalist and communist blocks: there are vast areas of capitalist societies which are not governed by capitalist principles, and there are many aspects of the socialist societies which cannot be described as socialist. You might even say that the only thing that makes life livable in the capitalist world is unacknowledged noncapitalist element within it, and the only thing that makes survival possible in the communist world is the unacknowledged capitalist element in it. This is why a controlled market is a left-wing demand in a capitalist economy—along with state control, while a free market is a left-wing demand in a communist society—along with workers' control. In both cases, the demands are for whittling away power from the centre, whether it is the power of the state or capitalism, or state-capitalism.

From *Anarchy in Action* (Freedom Press, 1969).

So what are the prospects for increasing the anarchist content of the real world? From one point of view the outlook is bleak: centralised power, whether that of governments or super-governments, or of private capitalism or the super-capitalism of giant international corporations, has never been greater. The prophesies of nineteenth-century anarchists like Proudhon and Bakunin about the power of the state over the citizen have a relevance today which must have seemed unlikely to their contemporaries.

From another standpoint the outlook is infinitely promising. The very growth of the state and its bureaucracy, the giant corporation and its privileged hierarchy, are exposing their vulnerability to non-cooperation, to sabotage, and to the exploitation of *their* weaknesses by the weak. They are also giving rise to parallel organisations, counter organisations, alternative organisations, which exemplify the anarchist method. Industrial mergers and rationalisation have bred the revival of the demand for workers' control, first as a slogan or a tactic like the work-in, ultimately as a destination. The development of the school and the university as broiler-houses for a place in the occupational pecking-order have given rise to the de-schooling movement and the idea of the anti-university. The use of medicine and psychiatry as agents of conformity has led to the idea of the anti-hospital and the self-help therapeutic group. The failure of Western society to house its citizens has prompted the growth of squatter movements and tenants' cooperatives. The triumph of the supermarket in the United States has begun a mushrooming of food cooperatives. The deliberate pauperisation of those who cannot work has led to the recovery of self-respect through Claimants' Unions.

Community organisations of every conceivable kind, community newspapers, movements for child welfare, communal households have resulted from the new consciousness that local as well as central government exploit the poor and are unresponsive to those who are unable to exert effective pressure for themselves. The "rationalisation" of local administration in Britain into "larger and more effective units" is evoking a response in the demand

for neighbourhood councils. A new self-confidence and assertion of their right to exist on their own terms has sprung up among the victims of particular kinds of discrimination—black liberation, women's liberation, homosexual liberation, prisoners' liberation, children's liberation: the list is almost endless and is certainly going to get longer as more and more people become more and more conscious that society is organised in ways which deny them a place in the sun. In the age of mass politics and mass conformity, this is a magnificent reassertion of individual values and of human dignity.

None of these movements is yet a threat to the power structure, and this is scarcely surprising since hardly any of them existed before the late 1960s. None of them fits into the framework of conventional politics. In fact, they don't speak the same language as the political parties. They talk the language of anarchism and they insist on anarchistic principles of organisation, which they have learned not from political theory but from their own experience. They organise in loosely associated groups which are *voluntary, functional, temporary* and *small*. They depend, not on membership cards, votes, a special leadership and a herd of inactive followers but on small, functional groups which ebb and flow, group and regroup, according to the task in hand. They are networks, not pyramids.

At the very time when the "irresistible trends of modern society" seemed to be leading us to a mass society of enslaved consumers they are reminding us of the truth that the irresistible is simply that which is not resisted. Obviously a whole series of partial and incomplete victories, of concessions won from the holders of power, will not lead to an anarchist society. But it will widen the scope of free action and the potentiality for freedom in the society we have. . . .

The idea of one-step, once-for-all revolution has its attractions. But such compromises of anarchist notions would have to be made, such authoritarian bedfellows chosen, for a frontal attack on the power structure, that the anarchist answer to cries for revolutionary unity is likely to be "Whose noose are you inviting me to put round my neck this time?"

Standing Bail
Albert Meltzer

IF I "HAD DONE THE STATE some service" at any time, albeit reluctantly, and they didn't know or appreciate it, it was surely in the number of times I have gone bail. In theory people are innocent until found guilty, but this is only in legal theory, not in practice. I must have saved the taxpayer thousands of pounds and saved dozens of homes.

When I was quite young, still with the boxing academy, John, a colleague, was charged on suspicion of burglary. Two men, whom he did not know, were caught in the act of armed robbery in London but a third escaped on John's motor-bike. He was visiting his parents in Cardiff, and this alibi was proved immediately on his arrest the same night. Had he said the bike was stolen he would have been in the clear, but he admitted letting "a friend" borrow the keys when he was away, yet declined to name the person. A girlfriend had, unknown to him, loaned it to another lover. Not until the driver was arrested two months later, possibly on information from the other two concerned in the hold-up, was he released from custody. That two months imprisonment "on remand" merely for being chivalrous, cost him his job, his flat and his possessions, which were nobody's concern. In fact his financial loss was greater than the fine imposed on the real driver, given credit for his story that he came forward voluntarily.

This early experience of injustice when I was too young to intervene may have led me into persistently going bail not just for friends, but for people I did not particularly know and once even for someone I never met. Visiting a political prisoner once in Brixton I met a woman in the waiting room who told me her

From *I Couldn't Paint Golden Angels* (AK Press, 1996).

friend was held in custody for an assault on a local drug dealer who had defrauded him. Bail was set at £100. She was not accepted so I offered to act as bailee. The case came up six months later and was dismissed as the dealer had disappeared. Let alone the prisoner, I saved the taxpayer a thousand pounds on this occasion alone. I was never let down by anyone, which was just as well considering some of the ridiculously high amounts I have been asked to stand in default of the prisoner appearing which could not possible have been met and which certainly wouldn't have been credited against the money I saved the Crown in forced board and lodging.

I found that in the Forties and Fifties judges still clung to the antiquated and long illegal notion that if people did not take the oath it was because they intended to commit perjury and feared hellfire if they swore on the Book. Alternatively, as I myself was asked at a court martial, "does your atheism in any way impede your telling the truth?" Mr Justice King-Hamilton, a staunch defender in the court of the privileges from criticism of Christianity and Islam, but not of Freethought, a Jew and not even an orthodox one, revived this notion in the Persons Unknown case in the Seventies.

Anarchists against Hanging
Philip Sansom

IT IS NOT GENERALLY APPRECIATED THAT the campaign [in Britain] against capital punishment, which so agitated the public mind in the 1950s, began with London anarchists. It might be said that anarchists have a special interest since in the past so many of our comrades have suffered from it, but I am prepared to argue that our standpoint was principled.

The initiative in this instance came not from Freedom Press or the London Anarchist Group (LAG), but from two individual anarchists, Kitty Lamb and Gerald Kingshott, who asked us to help in starting a campaign. There had been a very disturbing case in which two youths had been caught in a burglary. One was captured, then the other produced a gun and killed a policeman. The killer, being only sixteen, could not be hanged and was sentenced to Borstal [a type of youth detention centre, named after the village where the first of them was opened]. The other, who had been in custody when the policeman was shot, was eighteen; he was sentenced to death and hanged. The general feeling was, if a copper is killed, *someone* has to die.

LAG organised two large meetings that were held at St. Pancras Town Hall. The first was on 18th February 1983, with Kitty Lamb in the chair, and a varied bag of speakers—Donald Soper (Methodist), F.A. Ridley (Independent Labour Party), C.H. Normand (lawyer), Frank Dawtry (Prison Reform), Sybil Morrison (Peace Pledge Union), myself (LAG), and Sidney Silverman, the Labour [Party] MP who was eventually to steer the abolition bill through the House of Commons.

The second meeting followed quickly with Canon Carpenter, Victor Yates MP, Jean Henderson, Robert Copping, Sidney Silverman,

From 'Freedom Press and the Anarchist Movement in the '50s and '60s' in *Freedom: A Hundred Years*, the Freedom centenary edition, 1986.

Philip Sansom speaking in Hyde Park Speakers' Corner in 1967

F.A. Ridley, myself, a speaker from Norway (which had managed without the death penalty since 1902!), and Gerald Kingshott in the chair. At both meetings the chairpersons read out many telegrams of support from sympathetic writers, politicians, actresses, etc.

By the time of the second meeting, we had given ourselves the name of "The League Against Capital Punishment," This was the foundation of the National Campaign for the Abolition of Capital Punishment . . . eventually to see the diminutive Sidney Silverman triumphant. In all the self-congratulation of the influential who had joined the campaign after it got going, few, I suspect, raised their champagne glasses to Kitty Lamb and Gerald Kingshott, who had sparked the whole thing off.

No doubt some of our readers are now looking with horror on all the hobnobbing with MPs, intellectuals and other reformists, and wondering what it has to do with anarchism. Well, this much: if we can reduce, even by a little, the right (?) of the state to exercise powers of life and death, we are reversing the 20th century trend of absolute state power. I, for one, was not always comfortable in the company I shared on anti-hanging platforms but after all, what we were seeking was a reform which could only be carried out by Parliament. Would it have been better for the gruesome practice of state murder to have carried on?

The Relevance of Anarchism
Bill Christopher, Jack Robinson, Philip Sansom, and Peter Turner

ANARCHISM IS A PHILOSOPHY OF FREEDOM. It is a body of revolutionary ideas which reconciles, as no other revolutionary concept does, the necessity for individual freedom with the demands of society. It is a commune-ist philosophy which starts from the individual and works upwards, instead of starting from the State and working downwards. Social structure in an anarchist society would be carefully and consciously kept to a minimum and would be strictly functional; where organisation is necessary, it would be maintained, but there would be no organisation for its own sake. This would help to prevent the hardening of organisations into institutions—the hard core of government.

The heart of anarchism is its opposition to government. Not just a particular Government, but government as an institution. This is explicitly expressed in the word "anarchism" meaning the philosophy or ideology which aims at "anarchy": the absence of government. The aim is shared by other ideologies—socialist and communist—who see the "withering away of the State" as a desirable goal, but conceive the way towards that goal as lying through the use of the very institutions they want to abolish. Anarchists maintain that the use of these repressive institutions in the name of the revolution, or of progress, or of freedom, corrupts the revolution, inhibits progress and crushes freedom.

For anarchists, the end determines the means. If your end is a society without government, then you do not do anything to support the idea or fact of government or to encourage the idea that

Written and published by the editors of *Freedom* in 1970 and included in *The State Is Your Enemy*, ed. Charles Crute (Freedom Press, 1991).

government can in any way be desirable. If your aim is the abolition of the State—which is the concentration of the institutions of government—then you do nothing to encourage the life of the State by pretending it can be used for liberation: All the means by which people are governed are anathema to anarchism.

This adds up to a coherent and logical ideology and within itself anarchism is a perfect set of ideas. In its application to the existing "real" world, however, it is being applied to very imperfect situations. And furthermore, anarchists themselves differ in their interpretations of anarchism, both in relation to current events and in the emphasis they put upon the various aspects of the overall philosophy.

This can lead to apparent contradictions. Anarcho-syndicalists who advocate the abolition of the wage system support workers on strike for higher wages; individualists who are opposed to the State see no reason why they should not avail themselves of the social services when they are unemployed; anti-parliamentarians support the abolition of a law (hanging, abortion, homosexuality) which can only be done through Parliament; anti-imperialists condemn "national liberation" movements which are fighting an imperialist oppressor; anti-war militants who have gone to prison rather than take up arms support a violent revolution . . . and so on.

This is not quite so absurd as it may appear. We have to live in the world as it is—but as anarchists we are going to do our damnedest to make it as we would like it to be. We know how beautiful life could be, but we have to start from the ugly reality.

Now each anarchist will make his own moves and if we respect each other we will respect our comrade's own scale of priorities. Thus, for example, the anarcho-syndicalist will be concerned primarily with achieving workers' control of industry, and this necessitates building up workers' confidence in their own powers. Every victory in even a minor struggle encourages this confidence; every defeat diminishes it. So the anarchist in an industrial context will throw in his effort to help win a dispute which perhaps in itself is

irrelevant as far as a money-less society is concerned, but which will teach the workers more about tactics, about the value of direct action, about their importance in society, the strength they gain through solidarity, the creativity of their work, their dignity as human beings—perhaps a hundred lessons.

For we should not forget that there are two sets of aspects of anarchism: the end and the means. We have implied the end: anarchy, the society without government or any of the means of government, without money and the wage system and the exploitation they bring; without the State which defends that exploitation through the law, the police, the prisons, the constitutional murder of the gallows or the gas chamber, all backed up by the army, navy and air force; the inculcation which passes for education, the subtle pressures of the bureaucracy and the Church. Anarchy means the replacement of these anti-social forces by free association and mutual aid, by free access to the means of life, by the joy of making and sharing and living. A delightful ideal!

Anarchism also means the struggle to achieve all this. A bitter struggle against ruthless forces which will apparently stop at nothing to maintain the power set-up as it is. The great advantage anarchism has is that it is not sidetracked into diversions like the parliamentary struggle, like "workers' government" or the "dictatorship of the proletariat," trying to achieve power in order to abolish it or the historical process or any other mythology. Anarchism teaches the governed to use their strength where it matters—at the point of production; and to use it in the way it matters—by direct action.

The means of freedom for the end of freedom: that is the relevance and strength of anarchism.

Notes on Contributors

Mikhail Alexandrovich Bakunin (1814–1876), a philosopher and historian, toured Europe in 1840 in preparation for a professorship at Moscow University, and became a revolutionary. After participating in an insurrection in Czechoslovakia he was imprisoned in St. Petersburg from 1849 until 1857, then exiled to a work camp in Siberia, from which he escaped to Japan and returned to Europe.

In 1868, at the Brussels conference of the International Working Men's Association (aka the First International), all participants embraced the socialist ideal of a society free of coercive institutions, organised entirely by voluntary cooperation. But there was a difference of opinion about how the ideal should be approached. One faction, led by Bakunin, was for opposing coercive institutions where and when they were found. The other faction, led by Karl Marx (1818–1883), was for amalgamating all coercive institutions into one super state, where elected leaders would guide the population to eventual freedom.

In 1872 there were two conferences, authoritarian socialists (Marx) meeting at The Hague, and anarchist socialists (Bakunin) at St. Imier. The split has not healed. Bakunin's prediction has since proved true in the cases of Stalin, Mao Zedong, and Kim Il Sung.

Alexander Berkman (1870–1936) was born in Vilnius, Lithuania (then part of the Russian Empire). In 1888 he migrated to America, where he became the lover and companion of Emma Goldman. In 1892, Henry Clay Frick, Manager of the Carnegie Steel Corporation in Homestead, Pennsylvania, hired 300 men from the Pinkerton Detective Agency ("Pinkerton thugs") to break a strike, causing the deaths of nine strikers and seven Pinkertons. Berkman shot and

stabbed Frick but failed to kill him, and served fourteen years in prison.

In 1917, Berkman and Goldman were convicted of undermining the war effort and sentenced to two years' imprisonment, seven months of which Berkman spent in solitary confinement for complaining about prison guards beating other prisoners. In 1919 they were among 248 people deported to Russia.

In 1920 they moved to France, where Berkman wrote several pamphlets, including *Now or Never: An ABC of Communist Anarchism*, first published in 1927 as a series of articles in Yiddish in the American periodical *Freie Arbeiter Stimme*.

Marie Louise Berneri (1918–1949) was studying psychology at the Sorbonne in Paris in 1937 when her father, fighting with Spanish anarchists in Barcelona, was shot by men wearing Communist armbands. In 1939 she married Vernon Richards, which automatically made her a British citizen, and joined the editorial group of *Revolt*, later *War Commentary* and *Freedom*. In 1945, she and the other editors, Vernon Richards, John Hewetson, and Philip Sansom, were charged with conspiracy to incite members of His Majesty's Forces to disaffection. The three men were imprisoned, but her case was dismissed because, as the law stood at the time, a wife who conspired with her husband committed no offence.

Her scholarly study *Journey through Utopia* was accepted for publication by Routledge and Kegan Paul in 1948, and published by them in 1950. She died in childbirth, with her baby, in April 1949.

Bill Christopher (twentieth century) was a member of several anarchist groups, and an editor of *Freedom* in 1970.

Tony Gibson (Hamilton Bertie Gibson, 1914–2001), the youngest of seven children of a highly placed Scottish family, absconded from his public school (highest rank of fee-paying school) as a teenager. Hunted down by private detectives hired by his family,

he insisted on his legal right not to return. In 1939, earning his living as an art school model, he posed for a photograph in advertisements for Brylcreem, a water-based substitute for hair oil. His clothes in the photograph were retouched to give him a Royal Air Force uniform, but he was in prison as an unregistered conscientious objector. (The term "Brylcreem boy" was first used for Tony's photograph, and in later used in photographs of Denis Compton, a professional cricket player.)

After the war, as a father of two, Tony taught at a progressive school in London, organised holiday camps for children, and wrote a Freedom Press book, *Youth for Freedom, Freedom for Youth*. In 1951 he inherited enough money to study for a degree in sociology at London School of Economics, then won scholarships to sturdy for a doctorate in psychology at the Institute of Psychiatry in London, then as a researcher at Cambridge University Institute of Criminology. In 1970 he founded the Psychology Department at the University of Hertfordshire, where he stayed until retirement in 1976. He wrote articles for *Freedom* using the name Tony Gibson, and psychology books as Dr. H.B. Gibson.

William Godwin (1756–1836) was an English philosopher, novelist and journalist, husband of the feminist writer Mary Wollstonecraft, associate of the poet Percy Bysshe Shelley, and father of Mary Shelley, the author of *Frankenstein*.

Emma Goldman (1869–1940) was a writer, who could attract audiences of thousands to her speeches on anarchism, women's rights, and social issues. In 1906, she was imprisoned for distributing literature on birth control. In 1917, she and her lover Alexander Berkman were sentenced to two years in prison for "inducing people not to register" for conscription, and after they had served their time deported to the Soviet Union, where they agitated against Trotsky's attacks on the striking Kronstadt sailors. Later she married James Colton so she could obtain a British passport, and con-

tributed articles to the anarchist paper *Spain and the World*. She died in Canada.

John Hewetson (1913–1990) was a physician, one of the four editors of *War Commentary for Anarchism*, charged in April 1945 with inciting disaffection among His Majesty's Forces. At the time of his arrest he was a casualty officer at Paddington hospital, London, where he had been treating the victims of bombing. After release from prison he worked as a general practitioner. Many general practitioners at the time refused birth control advice, especially to unmarried women, so John provided it free to women whether or not they were on his NHS list.

As an editorial contributor to *War Commentary*, he wrote in favour of a woman's right to choose, as early as 1942. He did not himself perform abortions, which were illegal, but referred patients to an illegal specialist he knew. The introduction of the National Health Service, in 1948, was resisted by many physicians, fearing it might damage their income, but like most socialists and anarchists, John was in favour of providing medical services according to need. He embraced the unorthodox theories of Wilhelm Reich.

Peter Kropotkin (1842–1921) was born into the second tier of the Russian aristocracy. At the age of fourteen he joined the Corps of Pages, a military group of boys attached to the royal household in St. Petersburg. In 1962 he was promoted to the army, and in 1964 was put in command of a geographical expedition to Siberia, where he showed that the earlier maps were mistaken about the general structure of the land. In 1867 he resigned his commission to become a student of mathematics, and was disinherited for not following family tradition, but led geographical expeditions to Finland and Sweden for the university geographical society.

In 1974 he was imprisoned for revolutionary activity in the Peter and Paul Fortress in St. Petersburg, but allowed to continue geographical work because of his aristocratic rank. He escaped

in 1876 and went to Switzerland and France, where he was again imprisoned. In 1886 he moved to London, where he wrote for *Freedom*, earning his living as a writer of geographical articles for *Encyclopaedia Britannica*.

He had stopped using his title "Prince" as a boy in the Corps of Pages, but his wife, a lady of humble origins, liked to be known as Princess Kropotkin. In 1914 he disagreed with the *Freedom* editorial group and returned to Russia, to support the war against Germany.

Errico Malatesta (1853–1932) was an anarchist activist, who was expelled from the University of Naples and spent a total of about ten years in prison in various countries. In 1881, he attended the international anarchist congress In London, and wrote *L'Anarchia* for an Italian-language paper published in London. This was translated into English as *Anarchism* and published as a serial in *Freedom* in the same year. In 1910 he settled in London to live a quiet life, earning his living as an electrician, writing for *Freedom* in English, and *Umanita Nova* and *Penserio e Volonta* in Italian.

He objected to "giving an official solution" to the problems of life in anarchy, but not to fictitious stories about anarchies.

Albert Meltzer (1920–1996) joined a boxing club at the age of fifteen and was taken by one of the boxers, a Scottish anarchist, to a meeting addressed by Emma Goldman. At question time, he spoke from the audience in defence of boxing. He became a friend and collaborator of Vernon Richards, founder and editor of *Spain and the World*, the continuation of *Freedom*.

In 1939, he and Richards went together to apply for registration as conscientious objectors, and were refused. Richards went to prison for a time, while Meltzer was conscripted into the Auxiliary Military Pioneer Corps, a regiment of men who would have been rejected as volunteers for the regular army, later renamed the Royal Pioneer Corps. He helped fellow members of the Corps, who were

illiterate, to write letters home. As a deserter, a recalled conscript, and after his release from conscription, he continued to contribute articles to *War Commentary* and *Freedom*.

In 1965, he left *Freedom* to found *Wooden Shoe* and the Wooden Shoe Press and bookshop, and later founded *Black Flag* and the Kate Sharpley Library.

William Morris (1834–1896) was a designer of wallpaper, textiles, furniture, glassware, printed books, tapestries, and stained glass windows, an important contributor to Victorian culture. A founding member of the Social Democratic Federation and the Fabian Society, he left these groups after they opted for parliamentary action, to found the Socialist League and start the socialist newspaper *Commonweal,* which he edited for six years, until he was replaced by the anarchist Frank Kitz. He then left the paper, but settled its debts as he went, and continued to employ Kitz as a dyer at his factory.

The society described in *News from Nowhere* is certainly an anarchy, but its origin, in the story, was the abolition of government by Act of Parliament, so Morris is not generally regarded as an anarchist. He sometimes called himself a Marxist.

George Nicholson (twentieth century) was a contributor to *Freedom*.

Pierre-Joseph Proudhon (1809–1865) was the first writer to describe himself as an anarchist. The son of a cooper, he was taught to read at home, and at the age of ten awarded a scholarship, which paid most of his school fees, where he studied Latin and mathematics. His family could not afford shoes or books, so he went to school in wooden *sabots* and borrowed books from the school library. In 1830 he completed his apprenticeship as a compositor. Setting the type for a book, he corrected the Latin of the manuscripts, and the author paid for him to attend university. He got a

job as a journalist, with sufficient spare time to write philosophical works.

Vernon Richards (1915–2001) was originally named Vero Recchioni, and was always known as Vero to his friends. His father, Emidio Recchioni, was a prosperous restaurateur and delicatessen owner in Soho, London. As a boy, Vero was taken by his father to Paris, ostensibly to see the sights, but left to his own devices in a hotel room, while his father was (allegedly) conspiring to finance an attempt to assassinate Mussolini. Reporting the failed attempt, the *Daily Telegraph* mentioned Recchioni's name. Recchioni was paid damages for libel (which he used, it was said, to finance another attempt).

Vero graduated from University College London as a civil engineer, and took part in anarchist activity in Paris. He was arrested and deported in 1935. In 1936 he founded *Spain and the World*, with himself as editor. The paper was immediately recognised by the Freedom Press group as the continuation of *Freedom*, which had effectively ceased publication in 1932. The name was changed to *Revolt!*, then to *War Commentary for Anarchism*, and reverted to *Freedom* in 1946. The printer, in the East End of London which was suffering under the Blitz, was offered for sale in 1942, and Vero guaranteed a loan for Freedom Press to buy the business. Printing businesses which had been operative before the war were allowed to continue buying paper.

In 1944, when the four editors of *War Commentary* (Vero, John Hewetson, Philip Sansom, and Marie Louise Berneri) were charged with inciting disaffection among His Majesty's Forces, there was an attempt to seize Freedom Press and its assets by means of "Entryism," a method of taking over any organisation run by an elected majority, by joining in sufficient numbers to be voted into power. Spanish anarchists in exile, who had disagreed with British anarchists about support for the war, were now eligible to join the Anarchist Federation of Britain (AFB), and they packed a meeting,

at which a motion was passed to dismiss and replace the editors of *War Commentary*. The conspiracy failed, because Vernon Richards and John Hewetson had already been legally registered as proprietors of Freedom Press.

Vero always acted as one member of a cooperative group running Freedom Press, but although he preferred not to mention it, he was the financier, organiser, and proprietor from 1935 until 1982, when he handed it over to a nonprofit limited company he founded (with himself as one of the directors). Had he not founded *Spain and the World* in 1936, the anarchist movement in Britain would certainly have been very different, and might not have existed at all.

Vero (using the pseudonym "Freedom Press") originated, edited, and compiled *What Is Anarchism? An Introduction*, in 1992.

Jack Robinson (1921?–1983), born in Birmingham, was trained as a nurse. A conscientious objector in World War II, he worked in an epileptic colony and as a clinical volunteer in the study of Vitamin C deficiency. After the war, he toured the country and earned a living as a secondhand book dealer. After moving to London in 1953, he worked in Freedom bookshop with Lilian Wolfe, and later with his companion Mary Canipa, and he contributed many articles to *Freedom* and *Anarchy*.

Rudolf Rocker (1873–1958) was born in Mainz, Germany. His father died in 1877, his mother in 1887, and he was put in a Roman Catholic orphanage, from which he absconded. Recaptured after three days in the woods, he escaped again and got a job as a cabin boy on a river steamer, then was rescued by his uncle, Carl Rudolf Naumann, and apprenticed as a compositor. He attended the congress of the Second International in Brussels in 1891, and began contributing to the anarchist press.

In 1892, he narrowly escaped arrest at an anarchist meeting in Mainz and went to Paris, where he first met Jewish anarchists. Learning that he would be arrested if he returned to Germany, he

moved to London, then to Liverpool where he learned Yiddish so that he could work as a compositor for the Yiddish weekly *Dos Fraye Vort*. Back in London, he became the editor of the Yiddish anarchist paper *Arbeter Fraynd*, and in 1903 started the periodical *Germinal*.

In 1897, Rocker and his companion Milly Witkop tried to emigrate to America, but were refused admission because they were not legally married. They were allowed in, however, in 1929. His *Nationalism and Culture* was published in 1937, and *Anarcho-Syndicalism*, a history of anarchism from ancient times, in 1938.

Philip Sansom (1916–1999), the son of a lathe operator, trained as a commercial artist, became an anarchist in 1943. He was one of the four editors of *War Commentary* charged with inciting disaffection in 1945. He contributed reports, commentary, and cartoons to *Freedom*, and was well known as an eloquent, witty speaker and debater. He objected to being described as an anarchist leader, because the word "leader" is used for bosses and rulers, but he was the prime mover of many anarchist enterprises. In 1954, he collected a group to form the Malatesta Club, which rented a cellar in Holborn and was open every evening, staffed entirely by unpaid volunteers, for four years. In 1969, he led the occupation of the Cuban embassy in protest against the treatment of Cuban anarchists.

Max Stirner (pen name of Johann Kasper Schmidt, 1806–1856), an important contributor to anarchist thought, argues that no one sacrifices himself, or herself, for God, Country, Freedom, Humanity, Peace, Love, Society, or any other cause outside of themselves, that love and empathy are common human urges, and that everyone seeks only to satisfy his or her own urges. He advocates that we should not pretend, or try, to serve causes outside of our individual selves, but that each of us should frankly seek to gratify her or his individual urges, exploiting the efforts of people with similar urges, in a loving union of conscious egoists.

The difficulty is with his style. He writes in a mixture of colloquial language, formal philosophical language, slang, jokes, sarcasm, and references to stories with which he assumes his readers are familiar. It seems as if he jotted down phrases as they occurred to him, and left them as first written, rarely if ever going back to sort them into a better sequence, or to express them more concisely, so that the general structure is rambling and haphazard, with apt aphorisms and delightful metaphors popping up unannounced.

Further difficulties are added in the standard English translation, *The Ego and Its Own* (1907). The translator, Steven Byington, seems to have struggled without access to an adequate dictionary of German idioms. Stirner begins and ends the book with the first line of a poem by Goethe, *"Ich hab' Mein Sach' auf Nichts gestellt,"* which means "I have taken nothing as my cause." Readers must make what they can of Byington's rendering, "All things are nothing to me (literally, I have set my affair on nothing)."

Stirner's own title of his book, *Der Einzige und sein Eigenthum,* means "The unique person and her, his, or its property" (in English, the gender of the possessive pronoun is that of the possessor). The publisher of the English translation, Benjamin Tucker, gave it a new title: *The Ego and His Own,* which raises the question, "What does Stirner mean by The Ego?"; a question which has no answer, because Stirner does not mention The Ego (except in one stray sentence, criticising the use of the term by his contemporary Fichte).

Tucker's word "his" causes further problems for younger readers. Since 1970, the masculine gender is only used for the male sex, but in 1907 it was often used, as it was used by Tucker, to mean people in general including females. Two separate publishers (Rebel Press 1982 and Cambridge University Press 1995) have reissued the book as *The Ego and Its Own,* which corrects the false impression that it applies only to males, but actually augments the daft misunderstanding that it is about something called "The Ego." Advice to English-language readers: ignore the title and start by reading some of the text.

Peter Turner (twentieth century), a carpenter by trade, was a trade union activist, delegate to Trades Councils in London, member of various anarchist groups and participant in many anarchist activities. In 1970 he was an editor of *Freedom*.

Nicolas Walter (1934–2000) studied history at Oxford University after release from conscription in the Royal Air Force, with jobs including editor of *New Humanist* from 1989 until his retirement in 1999. He was a prolific writer of letters to newspapers and magazines, with more than two thousand letters published using his own name and many more using the pseudonyms Jean Raison, Arthur Freeman, and Mary Lewis. A meticulous researcher, he was first through the door of the new British Library building in 1997.

A published letter accused him of supposing that history consisted of nothing but the pedantic search for facts, and he replied, "Getting the facts right is not the whole of history, but it is an essential preliminary"—and went on to detail the factual errors in his accuser's letter.

His *About Anarchism* was published by Freedom Press in 1969, and reprinted several times. In 1980, he asked for no more reprints until he had revised the text, mostly to keep up with a change in accepted style. It had become improper to use the masculine gender "he" to mean people in general including females. But he never completed the revisions. In 1992, Vernon Richards suggested to Donald Rooum that he should write a pamphlet on anarchism as a stop-gap. The result forms the introductory pages of this book. An updated edition of *About Anarchism*, edited by Natasha Walter, was published by Freedom Press in 2002. PM Press issued a collection of his writings on anarchism and war resistance in 2011.

Colin Ward (1924–2010) first encountered anarchism as an army conscript in the 1940s. In 1945, his name was found on a List of subscribers to *War Commentary* (the wartime name of *Freedom*), and he was brought to London as a witness against the editors,

who were charged with inciting members of the armed services to disaffection. Despite his testimony being hostile to the prosecution, they were convicted. From 1947 to 1960 he was an editor of *Freedom*, and from 1961 to 1970 the editor of the Freedom Press monthly *Anarchy* (118 issues). He was employed as an architect for one of the London borough councils, then from 1971 as Education Officer for the Town and Country Planning association. He wrote more than thirty books on social issues, including the seminal *The Child and the City*.

As an anarchist writer and speaker, Colin was eager for anarchism to be recognised as intellectually respectable.

Charlotte Wilson (1854–1944) was the founder and first editor of *Freedom*. The wife of a stockbroker, she had studied at Cambridge University, but being a woman could not be awarded a degree. In 1884, as "An English Anarchist" she wrote a series of four articles for the magazine *Justice*, which was probably the first exposition of anarchist socialism in the English language. She also wrote "Anarchism," part of a Fabian Society tract, *What Socialism Is*, but resigned from the Fabian Society executive when it became Parliamentarian. In 1895 she helped to start Henry Seymour's *The Anarchist*, but Seymour, was an "individualist anarchist" (against the state but not against capitalist exploitation), and asked the socialist anarchists to leave.

She founded *Freedom* in October 1886, with herself as editor and Peter Kropotkin (recently released from prison in France) as the main columnist.

About the Author

Donald Rooum, born 1928, became an anarchist in 1944 and has contributed articles to the anarchist paper *Freedom* since 1947. He studied graphic design in Bradford, England, and his cartoons have been published in the British press since 1950. His editorial cartoons have appeared in *Peace News* since 1962. His strip series "Wildcat" has appeared in *Freedom* since 1980, and "Sprite" in *The Skeptic* since 1987. In 1963, he was charged with carrying an offensive weapon, but the prosecuting officer made a mistake in planting the evidence, and in working to save his own skin Donald accidentally initiated the celebrated "Challenor case," concerning a conspiracy among police officers to discredit nonviolent demonstrators.

About Vernon Richards

ACROSS SEVEN DECADES, VERNON RICHARDS MAINTAINED an anarchist presence in British publishing. His chosen instrument was Freedom Press, based in Whitechapel, in London's East End. He edited the anarchist paper *Freedom*—and its prewar and wartime variations—into the 1960s. Earlier, he had been imprisoned in 1945, translated the Italian anarchist Errico Malatesta, and photographed George Orwell.

About Andrej Grubačić

ANDREJ GRUBAČIĆ IS THE CHAIR OF the Anthropology and Social Change department at the California Institute of Integral Studies. His most recent book is *Don't Mourn, Balkanize: Essays after Yugoslavia* (2010). Andrej is a member of the International Council of the World Social Forum, the Industrial Workers of the World, and the Global Balkans Network. He is associated with Retort, a group of antinomian writers, artists, artisans, and teachers based in the San Francisco Bay Area.

ABOUT PM PRESS

PM Press was founded at the end of 2007 by a small collection of folks with decades of publishing, media, and organizing experience. PM Press co-conspirators have published and distributed hundreds of books, pamphlets, CDs, and DVDs. Members of PM have founded enduring book fairs, spearheaded victorious tenant organizing campaigns, and worked closely with bookstores, academic conferences, and even rock bands to deliver political and challenging ideas to all walks of life. We're old enough to know what we're doing and young enough to know what's at stake.

We seek to create radical and stimulating fiction and non-fiction books, pamphlets, T-shirts, visual and audio materials to entertain, educate, and inspire you. We aim to distribute these through every available channel with every available technology—whether that means you are seeing anarchist classics at our bookfair stalls; reading our latest vegan cookbook at the café; downloading geeky fiction e-books; or digging new music and timely videos from our website.

PM Press is always on the lookout for talented and skilled volunteers, artists, activists, and writers to work with. If you have a great idea for a project or can contribute in some way, please get in touch.

PM Press
PO Box 23912
Oakland, CA 94623
www.pmpress.org

FRIENDS OF PM PRESS

These are indisputably momentous times—the financial system is melting down globally and the Empire is stumbling. Now more than ever there is a vital need for radical ideas.

In the years since its founding—and on a mere shoestring—PM Press has risen to the formidable challenge of publishing and distributing knowledge and entertainment for the struggles ahead. With hundreds of releases to date, we have published an impressive and stimulating array of literature, art, music, politics, and culture. Using every available medium, we've succeeded in connecting those hungry for ideas and information to those putting them into practice.

Friends of PM allows you to directly help impact, amplify, and revitalize the discourse and actions of radical writers, filmmakers, and artists. It provides us with a stable foundation from which we can build upon our early successes and provides a much-needed subsidy for the materials that can't necessarily pay their own way. You can help make that happen—and receive every new title automatically delivered to your door once a month—by joining as a Friend of PM Press. And, we'll throw in a free T-shirt when you sign up.

Here are your options (all include a 50% discount on all webstore purchases):
- **$30 a month** Get all books and pamphlets
- **$40 a month** Get all PM Press releases (including CDs and DVDs)
- **$100 a month** Everything plus PM merchandise and free downloads

For those who can't afford $30 or more a month, we have **Sustainer Rates** at $15, $10 and $5. Sustainers get a free PM Press T-shirt and a 50% discount on all purchases from our website.

Your Visa or Mastercard will be billed once a month, until you tell us to stop. Or until our efforts succeed in bringing the revolution around. Or the financial meltdown of Capital makes plastic redundant. Whichever comes first.

Wildcat Anarchist Comics
Donald Rooum
Foreword: Jay Kinney
Colorist: Jayne Clementson
$14.95
ISBN: 978-1-62963-127-1
10x7 • 128 pages

Wildcat Anarchist Comics collects the drawings of Donald Rooum, mostly (but by no means entirely) from the long-running "Wildcat" cartoon series that has been published in *Freedom* newspaper since 1980. Rooum does not just purvey jokes but makes the drawings comical in themselves, "getting the humour in the line," provoking laughter even in those who do not read the captions or speech balloons.

The chief characters in the strip are the Revolting Pussycat, a short-fused anarchist who is furious and shouty; and the Free-Range Egghead, an intellectual who would like anarchism to be respectable but sometimes appears foolish. Governments, bosses, and authoritarians are presented as buffoons, and quite often so are anarchists. This thoughtful and delightful collection includes strips from *The Skeptic* and many more, all beautifully colored for the first time by Jayne Clementson.

The book also includes a lively autobiographical introduction that discusses Rooum's role in the 1963 "Challenor case," in which a corrupt police officer planted a weapon on Rooum at a demonstration, ultimately resulting in Rooum's acquittal.

Life and Ideas
The Anarchist Writings of Errico Malatesta

Errico Malatesta
Editor: Vernon Richards
Foreword: Carl Levy
$21.95
ISBN: 978-1-62963-032-8
9x6 • 320 pages

With the timely reprinting of this selection of Malatesta's writings, first published in 1965 by Freedom Press, the full range of this great anarchist activist's ideas are once again in circulation. Life and Ideas gathers excerpts from Malatesta's writings over a lifetime of revolutionary activity.

The editor, Vernon Richards, has translated hundreds of articles by Malatesta, taken from the journals Malatesta either edited himself or contributed to, from the earliest, *L'En Dehors* of 1892, through to *Pensiero e Volontà*, which was forced to close by Mussolini's fascists in 1926, and the bilingual *Il Risveglio/Le Réveil*, which published most of his writings after that date. These articles have been pruned down to their essentials and collected under subheadings ranging from "Ends and Means" to "Anarchist Propaganda." Through the selections Malatesta's classical anarchism emerges: a revolutionary, nonpacifist, nonreformist vision informed by decades of engagement in struggle and study. In addition there is a short biographical piece and an essay by the editor.

Anarchy and the Sex Question
Essays on Women and Emancipation, 1896–1926
Emma Goldman
Editor: Shawn P. Wilbur

$14.95
ISBN: 978-1-62963-144-8
8x5 • 160 pages

For Emma Goldman, the "High Priestess of Anarchy," anarchism was "a living force in the affairs of our life, constantly creating new conditions," but "the most elemental force in human life" was something still more basic and vital: sex.

"The Sex Question" emerged for Goldman in multiple contexts, and we find her addressing it in writing on subjects as varied as women's suffrage, "free love," birth control, the "New Woman," homosexuality, marriage, love, and literature. It was at once a political question, an economic question, a question of morality, and a question of social relations.

But her analysis of that most elemental force remained fragmentary, scattered across numerous published (and unpublished) works and conditioned by numerous contexts. *Anarchy and the Sex Question* draws together the most important of those scattered sources, uniting both familiar essays and archival material, in an attempt to recreate the great work on sex that Emma Goldman might have given us. In the process, it sheds light on Goldman's place in the history of feminism.

Wobblies and Zapatistas

Conversations on Anarchism, Marxism and Radical History

Staughton Lynd and Andrej Grubačić

$20.00
ISBN: 978-1-60486-041-2
8x5 • 300 pages

Wobblies and Zapatistas offers the reader an encounter between two generations and two traditions. Andrej Grubačić is an anarchist from the Balkans. Staughton Lynd is a lifelong pacifist, influenced by Marxism. They meet in dialogue in an effort to bring together the anarchist and Marxist traditions, to discuss the writing of history by those who make it, and to remind us of the idea that "my country is the world." Encompassing a Left-libertarian perspective and an emphatically activist standpoint, these conversations are meant to be read in the clubs and affinity groups of the new Movement.

The authors accompany us on a journey through modern revolutions, direct actions, antiglobalist counter-summits, Freedom Schools, Zapatista cooperatives, Haymarket and Petrograd, Hanoi and Belgrade, "intentional" communities, wildcat strikes, early Protestant communities, Native American democratic practices, the Workers' Solidarity Club of Youngstown, occupied factories, self-organized councils and soviets, the lives of forgotten revolutionaries, Quaker meetings, antiwar movements, and prison rebellions. Neglected and forgotten moments of interracial self-activity are brought to light. The book invites the attention of readers who believe that a better world, on the other side of capitalism and state bureaucracy, may indeed be possible.